GAILEARAÍ
NÁISIÚNTA na
hÉIREANN

N
G
IRELAND

DIARY 2022

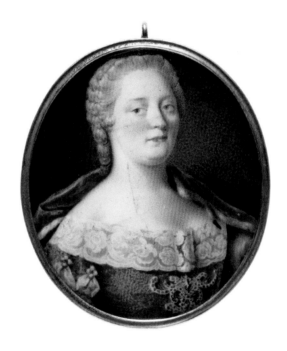

NATIONAL
GALLERY of
IRELAND

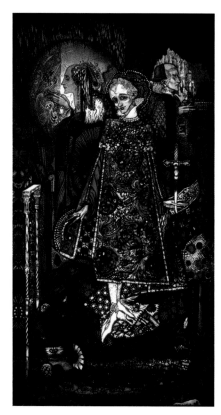

TITLE PAGE Giuseppe Macpherson, *Maria Theresa (1717–1780), Empress of Germany, Queen of Bohemia and Hungary,* **1740s**

This miniature depicts Empress Maria Theresa in the early years of her forty-year reign (1740–80). She is credited with reforming primary school education in Austria. Maria Theresa and her husband Emperor Francis I had 13 children who survived infancy. Following the smallpox epidemic of 1767, in which several of her children died, she promoted an inoculation programme throughout Austria. She contracted smallpox herself, and though she continued to rule until her death 13 years later, she never fully recovered.

THIS PAGE Harry Clarke, *The Song of the Mad Prince,* **1917**

Clarke's fantastical interpretation of Walter de la Mare's poem shows the distressed prince mourning his dead love at her grave, holding a crucifix-shaped dagger and a fan. Behind him are his parents, the king holding a key, the queen concentrating on her Rosary. Clarke plated a sheet of blue glass against a sheet of ruby glass, and worked both with pen and acid to produce intense colours, intricate patterns and a glittering, jewelled effect.

COVER John Butler Yeats, *Susan Mary (Lily) Yeats, (1866-1949), Embroiderer and Designer,* **1901**

John Butler Yeats drew or painted all his children, Jack, William, Elizabeth and Lily. In this portrait, Lily appears relaxed but has a strong presence. She sways slightly as she fixes her brown eyes on her father with a direct yet gentle gaze. A string of coral beads swings to one side as she tilts her body. The warmth of her personality and rapport with the artist make it one of Yeats's great portraits. Lily trained in embroidery with May Morris, daughter of William Morris, joined the Dun Emer Guild, and later established the Cuala Industries with her sister, Elizabeth.

BACK COVER George Inness, *A Seacoast, Evening,* **late 19th century**

Inness was one of the most prolific and important American artists of the 19th century. Inness sought to achieve depth of emotion, mood and atmosphere in his landscapes, combining physical and spiritual aspects of nature in order to capture the true essence of a location. He became a master of light, shadow and the emotive use of colour in his more mature works, making dramatic contrasts between threatening skies and shaded earth, as in *A Seacoast, Evening*.

ENDPAPERS Engraver: Henry Brocas the Younger, After Samuel Frederick Brocas, *The Corn Exchange, Burgh Quay and Custom House, Dublin,* **19th century**

GAILEARAÍ NÁISIÚNTA na hÉIREANN

NATIONAL GALLERY of IRELAND

www.nationalgallery.ie

Twitter @NGIreland

Facebook.com/nationalgalleryofireland

Gill Books
Hume Avenue, Park West, Dublin 12
www.gillbooks.ie

Gill Books is an imprint of M.H. Gill & Co.

© The National Gallery of Ireland 2021

978 0 7171 9256 4

Text researched and written by Sara Donaldson/NGI
Design by Tony Potter
Photography by Roy Hewson and Chris O'Toole/NGI

Print origination by Teapot Press Ltd
Printed in the EU

This book is typeset in Dax

The paper used in this book comes from the wood pulp of managed forests. For every tree felled, at least one tree is planted, thereby renewing natural resources.

A CIP catalogue record for this book is available from the British Library.

5 4 3 2 1

2022

January • Eanáir
M	T	W	T	F	S	S
27	28	29	30	31	1	2
3	4	5	6	7	8	9
10	11	12	13	14	15	16
17	18	19	20	21	22	23
24	25	26	27	28	29	30
31	1	2	3	4	5	6

February • Feabhra
M	T	W	T	F	S	S
31	1	2	3	4	5	6
7	8	9	10	11	12	13
14	15	16	17	18	19	20
21	22	23	24	25	26	27
28	1	2	3	4	5	6

March • Márta
M	T	W	T	F	S	S
28	1	2	3	4	5	6
7	8	9	10	11	12	13
14	15	16	17	18	19	20
21	22	23	24	25	26	27
28	29	30	31	1	2	3

April • Aibreán
M	T	W	T	F	S	S
28	29	30	31	1	2	3
4	5	6	7	8	9	10
11	12	13	14	15	16	17
18	19	20	21	22	23	24
25	26	27	28	29	30	1

May • Bealtaine
M	T	W	T	F	S	S
25	26	27	28	29	30	1
2	3	4	5	6	7	8
9	10	11	12	13	14	15
16	17	18	19	20	21	22
23	24	25	26	27	28	29
30	31	1	2	3	4	5

June • Meitheamh
M	T	W	T	F	S	S
30	31	1	2	3	4	5
6	7	8	9	10	11	12
13	14	15	16	17	18	19
20	21	22	23	24	25	26
27	28	29	30	1	2	3

July • Iúil
M	T	W	T	F	S	S
27	28	29	30	1	2	3
4	5	6	7	8	9	10
11	12	13	14	15	16	17
18	19	20	21	22	23	24
25	26	27	28	29	30	31

August • Lúnasa
M	T	W	T	F	S	S
1	2	3	4	5	6	7
8	9	10	11	12	13	14
15	16	17	18	19	20	21
22	23	24	25	26	27	28
29	30	31	1	2	3	4

September • Meán Fómhair
M	T	W	T	F	S	S
29	30	31	1	2	3	4
5	6	7	8	9	10	11
12	13	14	15	16	17	18
19	20	21	22	23	24	25
26	27	28	29	30	1	2

October • Deireadh Fómhair
M	T	W	T	F	S	S
26	27	28	29	30	1	2
3	4	5	6	7	8	9
10	11	12	13	14	15	16
17	18	19	20	21	22	23
24	25	26	27	28	29	30
31	1	2	3	4	5	6

November • Samhain
M	T	W	T	F	S	S
31	1	2	3	4	5	6
7	8	9	10	11	12	13
14	15	16	17	18	19	20
21	22	23	24	25	26	27
28	29	30	1	2	3	4

December • Nollaig
M	T	W	T	F	S	S
28	29	30	1	2	3	4
5	6	7	8	9	10	11
12	13	14	15	16	17	18
19	20	21	22	23	24	25
26	27	28	29	30	31	1

2023

January • Eanáir
M	T	W	T	F	S	S
26	27	28	29	30	31	1
2	3	4	5	6	7	8
9	10	11	12	13	14	15
16	17	18	19	20	21	22
23	24	25	26	27	28	29
30	31	1	2	3	4	5

February • Feabhra
M	T	W	T	F	S	S
30	31	1	2	3	4	5
6	7	8	9	10	11	12
13	14	15	16	17	18	19
20	21	22	23	24	25	26
27	28	1	2	3	4	5

March • Márta
M	T	W	T	F	S	S
27	28	1	2	3	4	5
6	7	8	9	10	11	12
13	14	15	16	17	18	19
20	21	22	23	24	25	26
27	28	29	30	31	1	2

April • Aibreán
M	T	W	T	F	S	S
27	28	29	30	31	1	2
3	4	5	6	7	8	9
10	11	12	13	14	15	16
17	18	19	20	21	22	23
24	25	26	27	28	29	30

May • Bealtaine
M	T	W	T	F	S	S
1	2	3	4	5	6	7
8	9	10	11	12	13	14
15	16	17	18	19	20	21
22	23	24	25	26	27	28
29	30	31	1	2	3	4

June • Meitheamh
M	T	W	T	F	S	S
29	30	31	1	2	3	4
5	6	7	8	9	10	11
12	13	14	15	16	17	18
19	20	21	22	23	24	25
26	27	28	29	30	1	2

July • Iúil
M	T	W	T	F	S	S
26	27	28	29	30	1	2
3	4	5	6	7	8	9
10	11	12	13	14	15	16
17	18	19	20	21	22	23
24	25	26	27	28	29	30
31	1	2	3	4	5	6

August • Lúnasa
M	T	W	T	F	S	S
31	1	2	3	4	5	6
7	8	9	10	11	12	13
14	15	16	17	18	19	20
21	22	23	24	25	26	27
28	29	30	31	1	2	3

September • Meán Fómhair
M	T	W	T	F	S	S
28	29	30	31	1	2	3
4	5	6	7	8	9	10
11	12	13	14	15	16	17
18	19	20	21	22	23	24
25	26	27	28	29	30	1

October • Deireadh Fómhair
M	T	W	T	F	S	S
25	26	27	28	29	30	1
2	3	4	5	6	7	8
9	10	11	12	13	14	15
16	17	18	19	20	21	22
23	24	25	26	27	28	29
30	31	1	2	3	4	5

November • Samhain
M	T	W	T	F	S	S
30	31	1	2	3	4	5
6	7	8	9	10	11	12
13	14	15	16	17	18	19
20	21	22	23	24	25	26
27	28	29	30	1	2	3

December • Nollaig
M	T	W	T	F	S	S
27	28	29	30	1	2	3
4	5	6	7	8	9	10
11	12	13	14	15	16	17
18	19	20	21	22	23	24
25	26	27	28	29	30	31

The National Gallery of Ireland Diary for 2022 offers some firm favourites among our rich collection, and some newer works, such as *Flanders Fields* by William Crozier. Many of the illustrations are fragile works on paper, which can only intermittently be on display. Most famously, of course, these include our Turner watercolours from the Henry Vaughan bequest that are such perennial favourites for visitors each January. This year there is much to catch up with, as the Gallery was closed due to the pandemic for the first four months of last year. The Turner show was cancelled for the first time in living memory. This autumn, though, a travelling Turner exhibition, comprising paintings and works on paper, will provide a wonderful opportunity to immerse oneself in his extraordinary achievements.

Not only Turner, but many other works in the collection, some illustrated here, were missed by visitors who flocked back joyfully when the doors reopened last May. The Gallery was a place of pleasure, of reflection, of calm and of joyous reunion with the works of art we hold for the nation. In a nod to the schedule of displays and exhibitions this year, we feature a portrait of James Joyce in February. This coincides with the centenary of the publication of *Ulysses* and a planned exhibition to celebrate this seminal book. An opening date of 02.02.22 has quite a ring to it.

The 2022 Diary contains so much of the breadth of life: human encounters of every kind, religious and secular, as they flow through works in our collection. They offer dramatic exchanges as much as quiet togetherness. The intimate family encounters depicted by Pierre Bonnard remind us of what we have needed to do in recent times: turning inwards and remaining within a tight vicinity over the course of the pandemic. The many landscapes contained within these pages, marking different seasons and places at home and abroad, remind us of what we have missed.

We will soon be sailing by, or flying over, Ireland's Eye near Howth, or taking a boat trip down the Seine in Paris, or seeing a glorious sunrise or sunset as captured by Turner. These handsome pages offer us the opportunity for a sumptuous inner journey, through the world we inhabit and through the galleries of our great institution. As these pages turn, we hope to whet the appetite for a visit to the Gallery, its displays and adventurous exhibitions.

Sean Rainbird, Director, National Gallery of Ireland

George Russell (AE), *Portrait of Iseult Gonne (Mrs Francis Stuart),* **20th century**

Iseult Gonne (1894–1954), the daughter of Maud Gonne, was considered a great beauty and attracted the admiration of literary figures including Lennox Robinson, Ezra Pound and W.B. Yeats. She married the Irish poet and novelist Francis Stuart, whom she first met at George Russell's home in 1918. Russell depicts her as an attractive brown-eyed young woman wearing her hair in a bun and a patterned blue blouse which is echoed by the deeper blue curtain behind her.

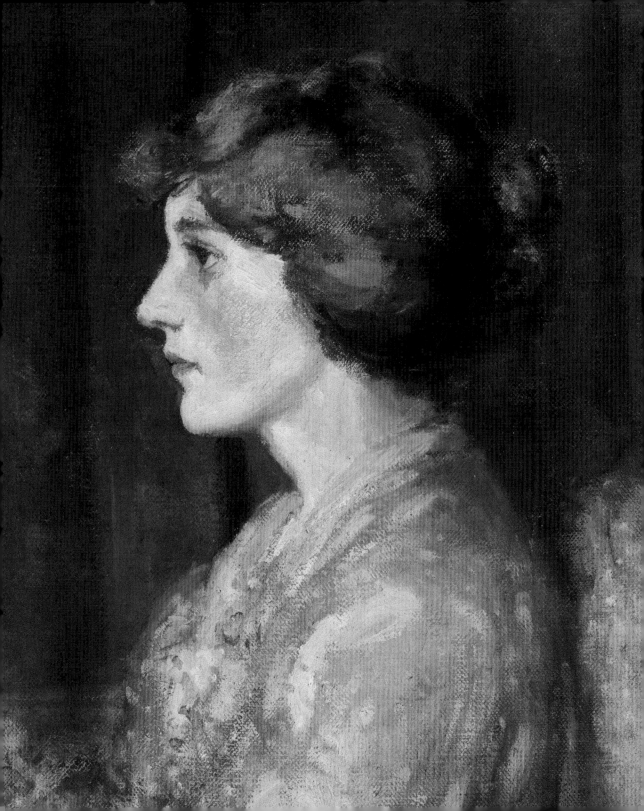

December · Nollaig
Week 52 · Seachtain 52

27 Monday · Luan

28 Tuesday · Máirt

29 Wednesday · Céadaoin

30 Thursday · Déardaoin

31 Friday · Aoine
New Year's Eve

1 Saturday · Satharn
New Year's Day

2022 January · Eanáir

2 Sunday · Domhnach

Roderic O'Conor, *Still Life with Apples and Breton Pots,* **c.1896–97**

In 1890 O'Conor settled in the village of Pont-Aven, Brittany, where, for over a decade, he felt the influence of the Post-Impressionist Paul Gauguin. In this vividly coloured still life, O'Conor utilises Breton produce: rustic, hand-painted ceramics and locally grown apples from which compote, cider and lambig, a form of Calvados, were made. The objects are placed on a table covered by a dark red cloth and the angle of the table appears to tilt up towards the viewer, as if defying gravity. O'Conor explores complementary colour contrasts in the juxtaposition of rich reds and greens.

M	T	W	T	F	S	S
27	28	29	30	31	1	2
3	4	5	6	7	8	9
10	11	12	13	14	15	16
17	18	19	20	21	22	23
24	25	26	27	28	29	30
31	1	2	3	4	5	6

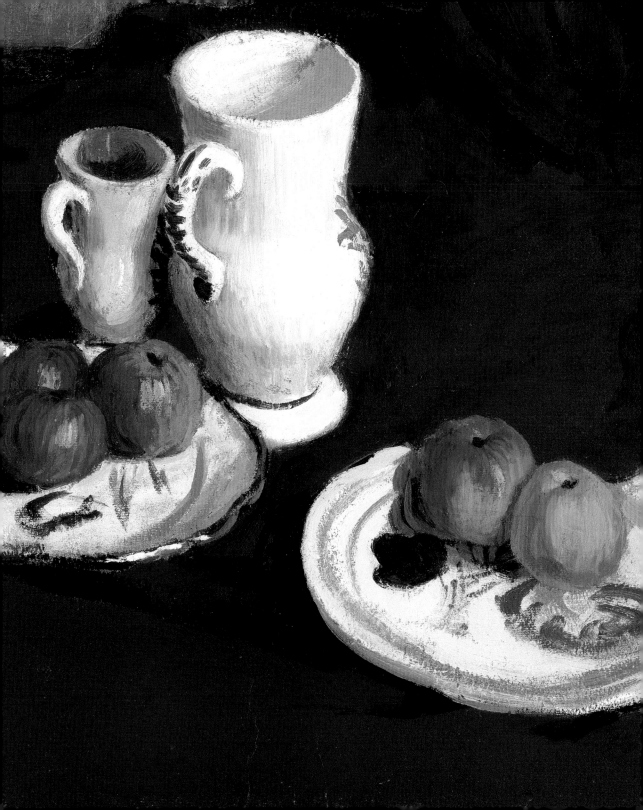

January · Eanáir
Week 1 · Seachtain 1

3 Monday · Luan

4 Tuesday · Máirt

5 Wednesday · Céadaoin

6 Thursday · Déardaoin

7 Friday · Aoine

8 Saturday · Satharn

9 Sunday · Domhnach

Sarah Purser, *Portrait of Kathleen Behan or The Sad Girl,* **1923**

Kathleen Kearney was a republican activist who worked as a receptionist for Maud Gonne. In c.1918–20, Gonne sent Kearney to Sarah Purser as an attractive model in need of employment, and she became Purser's favourite model from this time to the end of Purser's career, posing for portraits and nude studies in which her hazel eyes, full lips and thick red hair predominate. In this study her head, eyes and lips are down-turned in a pensive expression. The emotive handling of figure and background reveal Purser's painterly verve. Kearney married Stephen Behan, and their children included the writer Brendan Behan.

M	T	W	T	F	S	S
27	28	29	30	31	1	2
3	4	5	6	7	8	9
10	11	12	13	14	15	16
17	18	19	20	21	22	23
24	25	26	27	28	29	30
31	1	2	3	4	5	6

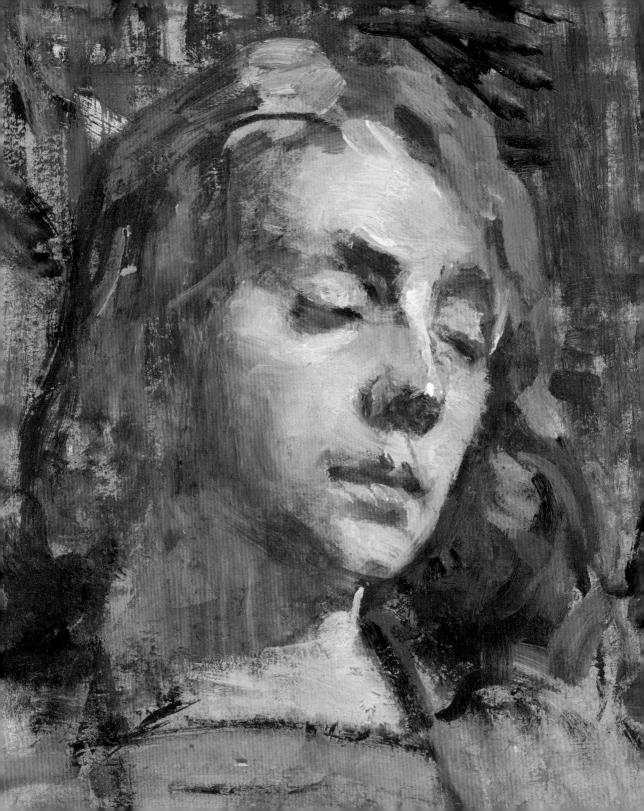

January · Eanáir
Week 2 · Seachtain 2

10 Monday · Luan

11 Tuesday · Máirt

12 Wednesday · Céadaoin

13 Thursday · Déardaoin

14 Friday · Aoine

15 Saturday · Satharn

16 Sunday · Domhnach

Gustave Caillebotte, *Banks of a Canal, near Naples,* **c.1872**

Caillebotte travelled from Paris to Italy in 1872. Captivated by the flat, arid landscape near Naples, he painted it bathed in sunlight *en plein air* (in the open air). In this view, believed to date from his Italian journey, he has adopted a vantage point slightly above eye level, looking down on the landscape. In this exercise in perspective, Caillebotte has experimented with the depiction of space, making the canal and road slice through the foreground at a dramatic angle and rush back towards the horizon line in the distance. The clear tones and unadorned landscape reflect his refusal to glamorise his subjects.

M	T	W	T	F	S	S
27	28	29	30	31	1	2
3	4	5	6	7	8	9
10	11	12	13	14	15	16
17	18	19	20	21	22	23
24	25	26	27	28	29	30
31	1	2	3	4	5	6

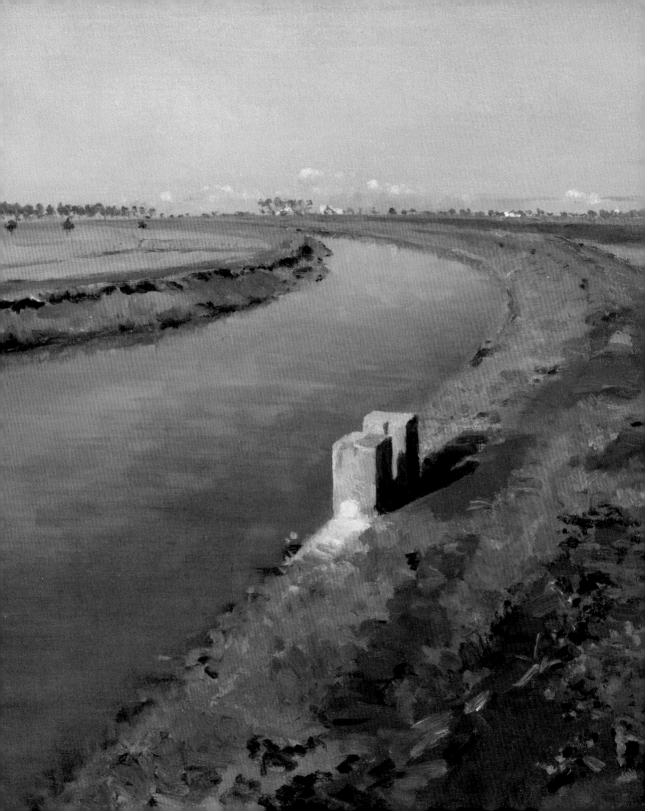

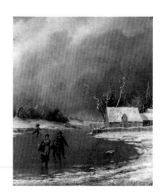

17 Monday · Luan

18 Tuesday · Máirt

19 Wednesday · Céadaoin

20 Thursday · Déardaoin

21 Friday · Aoine

22 Saturday · Satharn

23 Sunday · Domhnach

James Arthur O'Connor, *A Frost Piece,* **c.1825**

O'Connor wholly embraced and practised the landscape painting of the Romantic movement in his mature career. However, this small picture reveals the influence of Dutch 17th-century landscapes and winter scenes on his earlier work. In the foreground, a woman, man and child skate towards us, their clothing and faces unspecific to any period or place. In cool tones of grey and white, O'Connor has captured with great realism the tranquillity of this frozen river scene. The snow-covered rooftops of a cottage and distant church further enhance the chilly atmosphere.

M	T	W	T	F	S	S
27	28	29	30	31	1	2
3	4	5	6	7	8	9
10	11	12	13	14	15	16
17	18	19	20	21	22	23
24	25	26	27	28	29	30
31	1	2	3	4	5	6

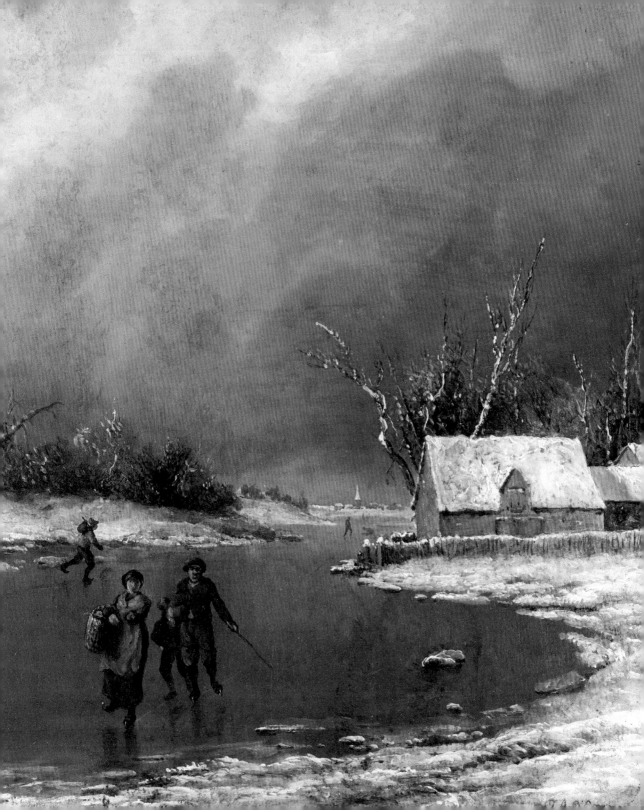

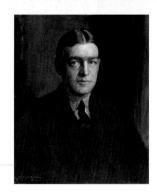

24 Monday · Luan

25 Tuesday · Máirt

26 Wednesday · Céadaoin

27 Thursday · Déardaoin

28 Friday · Aoine

29 Saturday · Satharn

30 Sunday · Domhnach

Charles Buchel, *Portrait of Ernest Shackleton (1874–1922), Polar Explorer,* **1920–21**

Born in Kilkea, Co. Kildare, Shackleton moved to London at age 10, left school at 16, and went to sea. Having trained on several ships, he joined the *Discovery* (1901-03) and *Nimrod* (1907–09) expeditions to Antarctica. Shackleton led the epic Imperial Trans-Antarctic Expedition (1914-17) involving the ill-fated *Endurance*. His final expedition left England on the *Quest* in September 1921. He died on board of heart failure in January 1922 in South Georgia, where he was buried. Buchel's portrait presents Shackleton as a handsome man whose smooth complexion and clear eyes belie his harrowing career as a fearless polar explorer.

M	T	W	T	F	S	S
27	28	29	30	31	1	2
3	4	5	6	7	8	9
10	11	12	13	14	15	16
17	18	19	20	21	22	23
24	25	26	27	28	29	30
31	1	2	3	4	5	6

31 Monday · Luan

1 Tuesday · Máirt February · Feabhra

2 Wednesday · Céadaoin

3 Thursday · Déardaoin

4 Friday · Aoine

5 Saturday · Satharn

6 Sunday · Domhnach

Jacques-Emile Blanche, *Portrait of James Joyce, (1882-1941), Author,* **1934**

Irish novelist and poet James Joyce was painted twice by Blanche while living in Paris. In this, the earlier portrait, Joyce is seated in three-quarter view, turning slightly towards the viewer. This angle was chosen as Joyce was concerned that a frontal pose would accentuate the thick lenses of his spectacles. While the pose and setting are informal, Joyce appears uncomfortable and his failing eyesight is suggested. A sense of tension is captured in both face and body language. Joyce, never easily pleased, wrote that he thought this portrait was 'awful, except for the splendid tie I had on'.

M	T	W	T	F	S	S
31	1	2	3	4	5	6
7	8	9	10	11	12	13
14	15	16	17	18	19	20
21	22	23	24	25	26	27
28	1	2	3	4	5	6

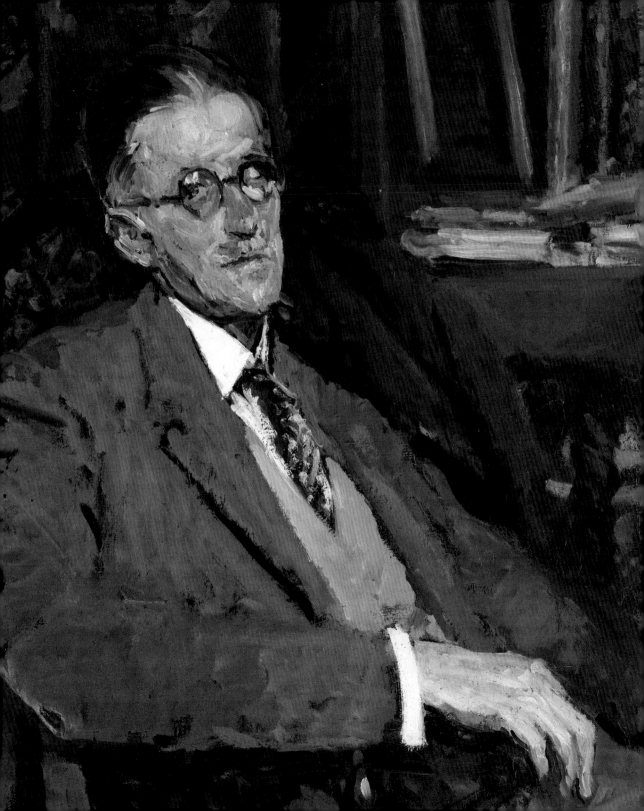

7 Monday · Luan

8 Tuesday · Máirt

9 Wednesday · Céadaoin

10 Thursday · Déardaoin

11 Friday · Aoine

12 Saturday · Satharn

13 Sunday · Domhnach

Bartolomé Esteban Murillo, *The Infant St John Playing with a Lamb,* **1670s**

In the Gospel of St Luke (1:80), St John the Baptist is described as having grown up in the desert. Murillo depicts him as an infant with the Lamb of God, a reference to St John's description of Christ when they met at the River Jordan. Wearing a brown animal skin and a vermilion cloak, he holds a cross made from a bamboo staff. The loose treatment of the loin-cloth and background, and the use of white impasto in the lamb's fleece, suggest that Murillo painted it in the 1670s.

M	T	W	T	F	S	S
31	1	2	3	4	5	6
7	8	9	10	11	12	13
14	15	16	17	18	19	20
21	22	23	24	25	26	27
28	1	2	3	4	5	6

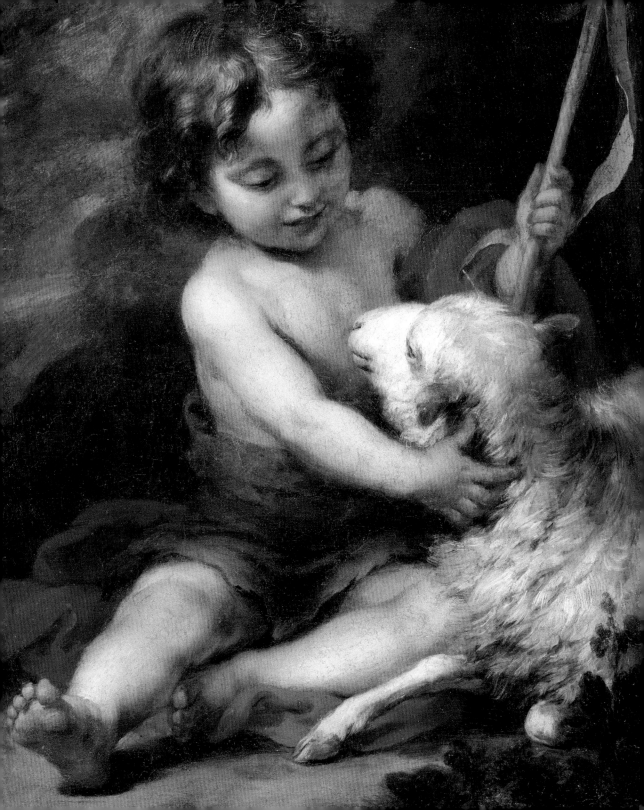

February · Feabhra
Week 7 · Seachtain 7

14 Monday · Luan
St Valentine's Day

15 Tuesday · Máirt

16 Wednesday · Céadaoin

17 Thursday · Déardaoin

18 Friday · Aoine

19 Saturday · Satharn

20 Sunday · Domhnach

Michael Angelo Hayes, *Sackville Street, Dublin,* **c.1853**
Originally named Drogheda Street after the Earl of Drogheda, from whom developer Luke Gardiner acquired the land, it was widened in c.1750, and renamed twice: in 1756, Sackville Street, after Lionel Cranfield Sackville, Lord Lieutenant of Ireland, and in 1930, O'Connell Street, after 'The Liberator', Daniel O'Connell. The portico of the General Post Office is topped by statues of Fidelity, Hibernia and Mercury by Thomas Kirk. Nelson's Pillar by William Wilkins, 1808–09, was crowned by Kirk's statue of Admiral Lord Nelson. Bombed in March 1966, the 40-metre pillar was demolished by the army a week later for safety reasons.

M	T	W	T	F	S	S
31	1	2	3	4	5	6
7	8	9	10	11	12	13
14	15	16	17	18	19	20
21	22	23	24	25	26	27
28	1	2	3	4	5	6

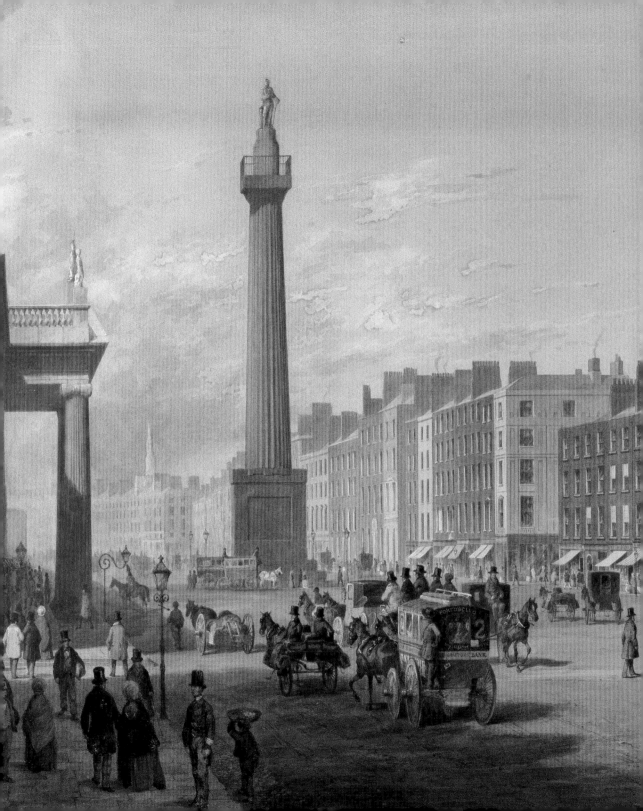

21 Monday · Luan

22 Tuesday · Máirt

23 Wednesday · Céadaoin

24 Thursday · Déardaoin

25 Friday · Aoine

26 Saturday · Satharn

27 Sunday · Domhnach

Félix François Georges Philibert Ziem, *Venice: A Scene with Boats,* **late 19th century**

Over 40 years, between the 1850s and 1890s, Ziem returned regularly to Venice, producing around a thousand views of a city which offered the perfect combination of architecture and sea, the two themes he most enjoyed painting. Ziem has taken this view from San Giorgio Maggiore where boats and gondoliers wait to carry passengers back to the mainland. The panorama of the Venice waterfront is suggested in the background, with the Doge's Palace, Campanile and St Mark's Square bathed in sunlight. In the tradition of J. M. W. Turner, Ziem sought to capture the eternal colour and atmosphere of the Doge's city.

M	T	W	T	F	S	S
31	1	2	3	4	5	6
7	8	9	10	11	12	13
14	15	16	17	18	19	20
21	22	23	24	25	26	27
28	1	2	3	4	5	6

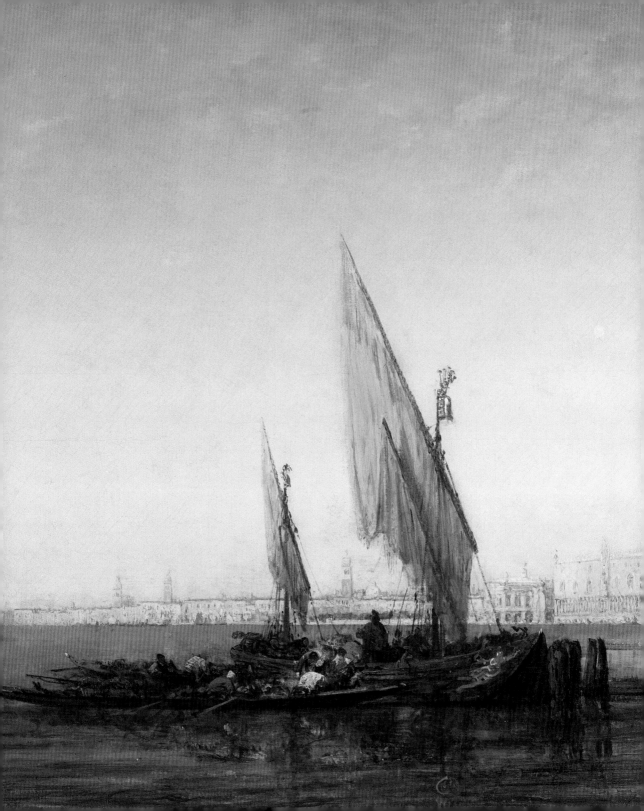

28 Monday · Luan

1 Tuesday · Máirt March · Márta

2 Wednesday · Céadaoin

3 Thursday · Déardaoin

4 Friday · Aoine

5 Saturday · Satharn

6 Sunday · Domhnach

Hercules Brabazon Brabazon, *A Street in Hamburg, Germany,* **19th century**

Brabazon was the youngest son of Hercules Sharpe of England, and Ann Brabazon of Co. Mayo, Ireland.
When his older brother died, he inherited the Brabazon surname and estates in the West of Ireland.
Hercules lived as an amateur painter, creating luminous watercolours of his extensive journeys in Europe,
North Africa and India. Admired by the critic John Ruskin as an heir to J. M. W. Turner, Brabazon joined
Ruskin on a sketching tour of Amiens, but his modernity was recognised in 1892 when he was discovered
by a younger generation of artists, including John Singer Sargent. From this time he exhibited professionally.

M	T	W	T	F	S	S
31	1	2	3	4	5	6
7	8	9	10	11	12	13
14	15	16	17	18	19	20
21	22	23	24	25	26	27
28	1	2	3	4	5	6

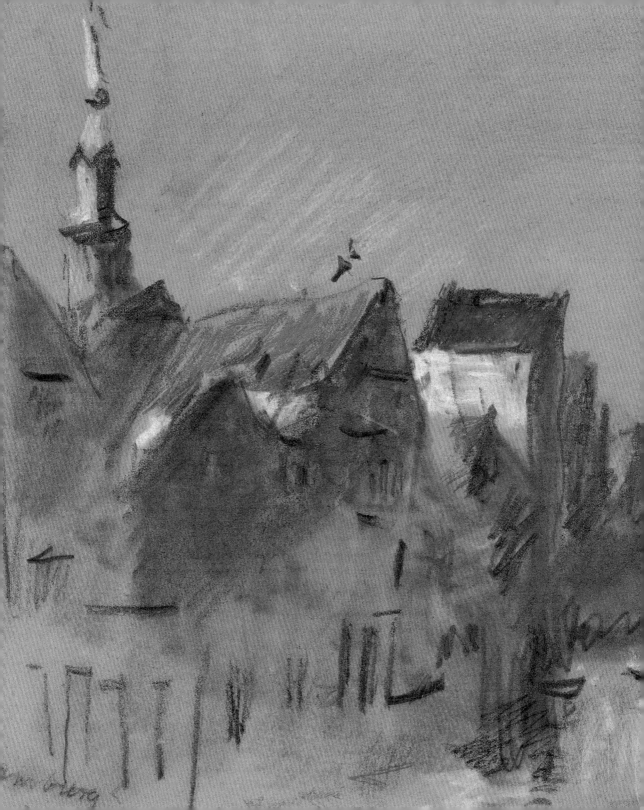

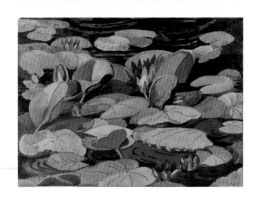

March · Márta
Week 10 · Seachtain 10

7 Monday · Luan

8 Tuesday · Máirt
International Women's Day

9 Wednesday · Céadaoin

10 Thursday · Déardaoin

11 Friday · Aoine

12 Saturday · Satharn

13 Sunday · Domhnach

Mainie Jellett, *A Water-Lily Pond,* **c.1930s**
Jellett studied Cubism in Paris with André Lhôte and Albert Gleizes and became a pioneer of abstract art in Ireland. A 1935 exhibition of Chinese art at the Royal Academy, London, changed her approach to landscape painting. The emphasis on pattern and rhythm in Chinese art inspired her to create a series of landscapes. The opaque density of the gouache medium reinforces the flatness of this decorative pattern of water-lilies and lily-pads, in which movement is on the surface and no attempt is made to create an illusion of depth.

M	T	W	T	F	S	S
28	1	2	3	4	5	6
7	8	9	10	11	12	13
14	15	16	17	18	19	20
21	22	23	24	25	26	27
28	29	30	31	1	2	3

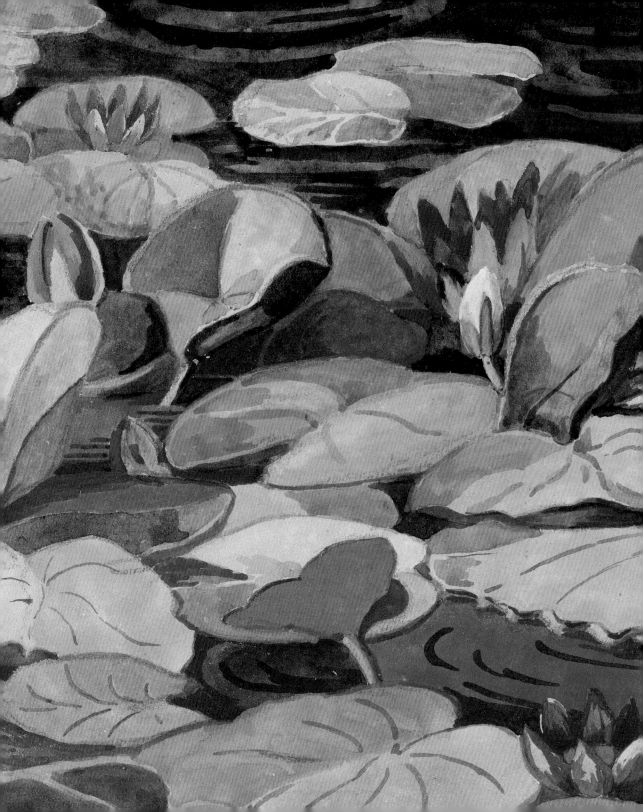

14 Monday • Luan

15 Tuesday • Máirt

16 Wednesday • Céadaoin

17 Thursday • Déardaoin
St Patrick's Day

18 Friday • Aoine

19 Saturday • Satharn

20 Sunday • Domhnach

James Barry, *The Baptism of the King of Cashel by Saint Patrick,* **c.1800–01**

Somewhat surprisingly, the talented Cork-born artist James Barry exhibited just one painting in Ireland during his lifetime, a finished version of this picture, which was purchased for the Irish House of Commons. This unfinished oil sketch represents Barry's return to the same subject 40 years after painting the original. He derived the subject from a 17th-century account of Irish history that appeared in English translation in 1723. According to the legend, St Patrick, while baptising the King of Cashel, accidentally pierced the monarch's foot with his crozier. The king endured his pain with dignity, refraining from reacting to the injury.

M	T	W	T	F	S	S
28	1	2	3	4	5	6
7	8	9	10	11	12	13
14	15	16	17	18	19	20
21	22	23	24	25	26	27
28	29	30	31	1	2	3

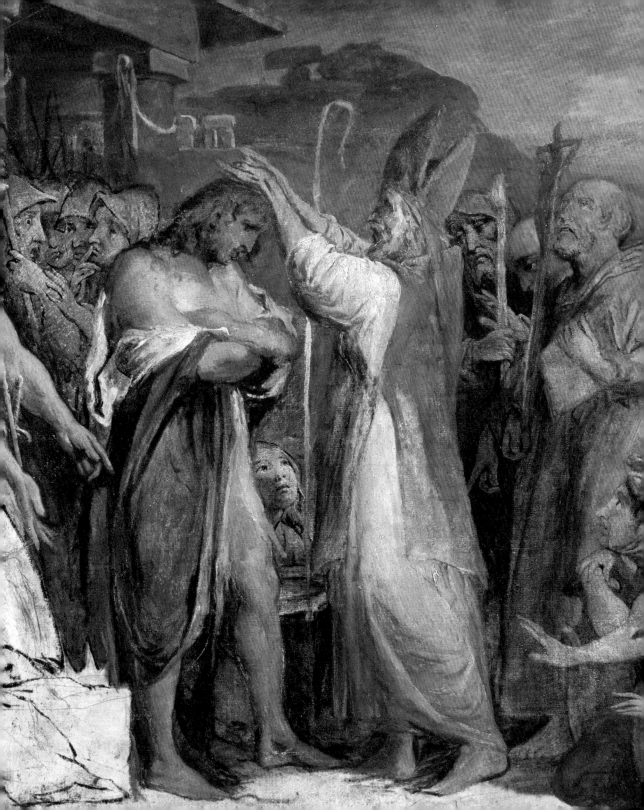

21 Monday • Luan

22 Tuesday • Máirt

23 Wednesday • Céadaoin

24 Thursday • Déardaoin

25 Friday • Aoine

26 Saturday • Satharn

27 Sunday • Domhnach
Mothering Sunday

Pierre Bonnard, *Nude before a Mirror,* **1915**

The intimate subject of a nude woman at her toilette within a domestic setting was one that Bonnard explored repeatedly. While he was known to use professional models, most of his nude studies were inspired by his muse, partner and eventual wife, Marthe de Méligny. She suffered from ill heath and followed medical advice by bathing frequently, an act which Bonnard recorded in many works. In this painting the woman is captured in a private moment, looking at her face in a mirror, a reflection that is shared with the viewer.

M	T	W	T	F	S	S
28	1	2	3	4	5	6
7	8	9	10	11	12	13
14	15	16	17	18	19	20
21	22	23	24	25	26	27
28	29	30	31	1	2	3

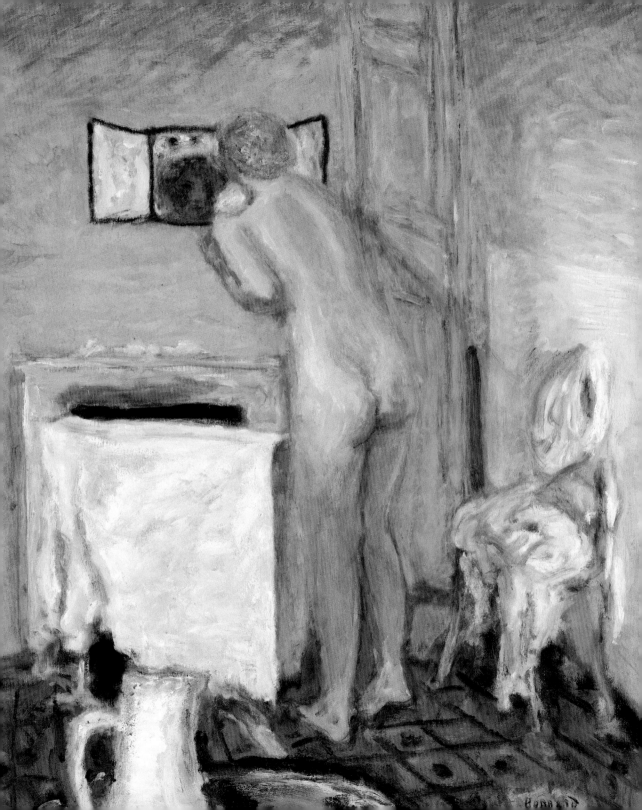

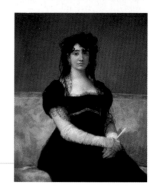

28 Monday • Luan

29 Tuesday • Máirt

30 Wednesday • Céadaoin

31 Thursday • Déardaoin

1 Friday • Aoine

April • Aibreán

2 Saturday • Satharn

3 Sunday • Domhnach

Francisco José de Goya y Lucientes, *Doña Antonia Zárate,* **c.1805–06**

This elegant lady was a celebrated actress and one of several stage personalities painted by Goya in Spain. An enthusiast of the theatre, Goya counted several playwrights, actors and actresses among his friends. He accentuates Antonia Zárate's dark beauty by setting off her black gown and lace mantilla against the yellow damask settee. In her hands she holds a *fleco* (fan), and her arms are covered with long white fingerless gloves. Her expression is direct, if slightly melancholic.

M	T	W	T	F	S	S
28	1	2	3	4	5	6
7	8	9	10	11	12	13
14	15	16	17	18	19	20
21	22	23	24	25	26	27
28	29	30	31	1	2	3

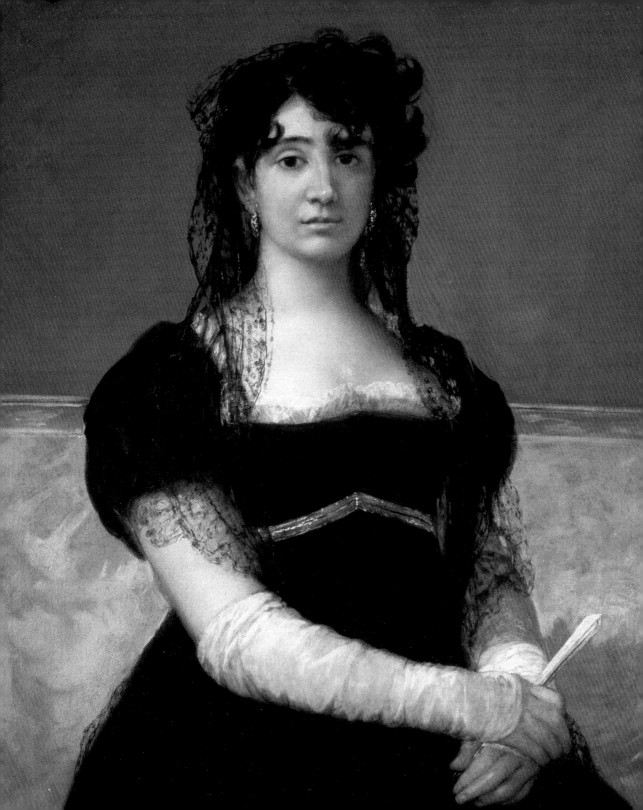

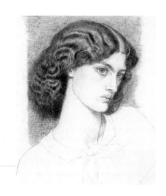

4 Monday · Luan

5 Tuesday · Máirt

6 Wednesday · Céadaoin

7 Thursday · Déardaoin

8 Friday · Aoine

9 Saturday · Satharn

10 Sunday · Domhnach

Dante Gabriel Rossetti, *Jane Burden as Queen Guinevere,* **1858**

The Pre-Raphaelite artist Dante Gabriel Rossetti met the sensuously attractive Jane Burden in 1857. She became his muse and later his lover, despite her marriage to the designer William Morris. This beautiful drawing may be Rossetti's first portrait of Jane, made when she was 18, and it depicts her in the guise of Queen Guinevere. It is a preliminary study for one of a series of uncompleted frescos illustrating the legend of King Arthur, which were planned for the walls of the Oxford Union Society building.

M	T	W	T	F	S	S
28	29	30	31	1	2	3
4	5	6	7	8	9	10
11	12	13	14	15	16	17
18	19	20	21	22	23	24
25	26	27	28	29	30	1

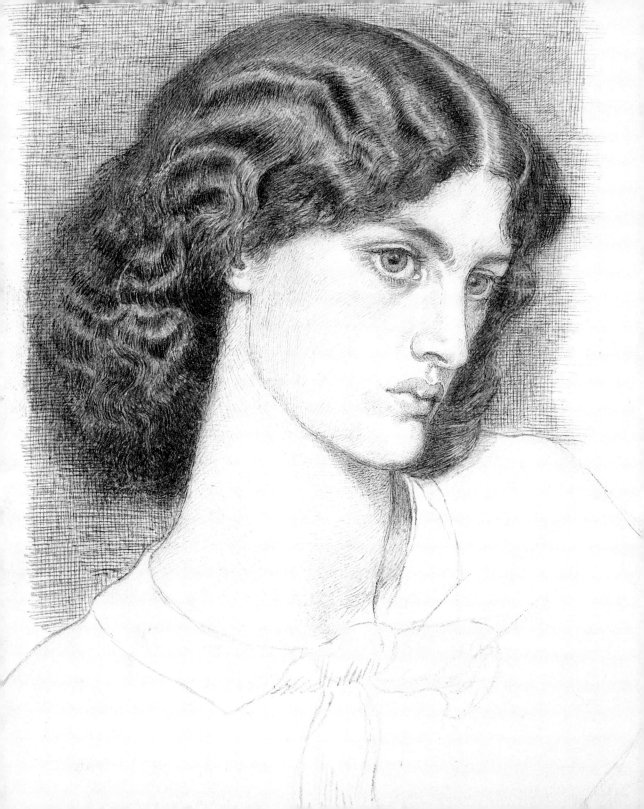

11 Monday · Luan

12 Tuesday · Máirt

13 Wednesday · Céadaoin

14 Thursday · Déardaoin

15 Friday · Aoine
Good Friday

16 Saturday · Satharn

17 Sunday · Domhnach
Easter Sunday

Robert Ponsonby Staples, *Ireland's Eye from Howth,* **1899**

Ponsonby Staples has combined graphite, pastel, chalk and watercolour to create a fresh and spontaneous landscape, which was more than likely painted rapidly *en plein air* (in the open air). Beyond a haystack, the Martello tower to the left of Ireland's Eye can be detected, balanced on the right by the huge, blue-tinged, free-standing rock known as 'the Stack'. Lambay Island is visible in the distance. The openness of the North Dublin coastline is conveyed in this view which, unusually for the artist's work, is devoid of human figures.

M	T	W	T	F	S	S
28	29	30	31	1	2	3
4	5	6	7	8	9	10
11	12	13	14	15	16	17
18	19	20	21	22	23	24
25	26	27	28	29	30	1

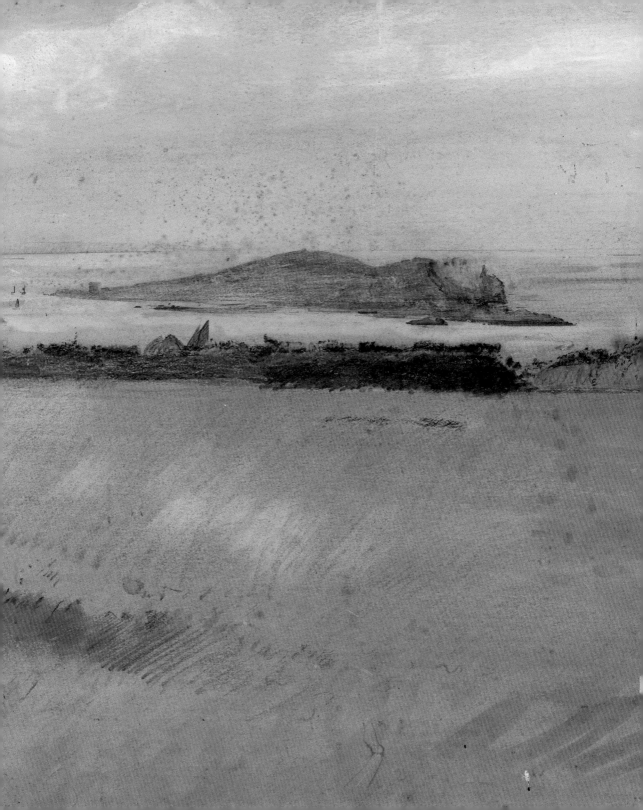

18 Monday · Luan
Easter Monday

19 Tuesday · Máirt

20 Wednesday · Céadaoin

21 Thursday · Déardaoin

22 Friday · Aoine

23 Saturday · Satharn

24 Sunday · Domhnach

William Crozier, *Flanders Fields,* **1962**

By the early 1960s, Crozier was widely regarded as one of the most exciting artists in the London art scene. *Flanders Fields* is an evocative rather than a literal title, although Crozier often spoke at this time about the effect on him of the horrors of war, especially those of the First World War. In the 1960s he began to paint skeletal human figures inhabiting bleak landscapes. Here, an isolated figure cowers in the corner of a vividly coloured landscape, projecting a feeling of anxiety and unease, vulnerability and mortality.

M	T	W	T	F	S	S
28	29	30	31	1	2	3
4	5	6	7	8	9	10
11	12	13	14	15	16	17
18	19	20	21	22	23	24
25	26	27	28	29	30	1

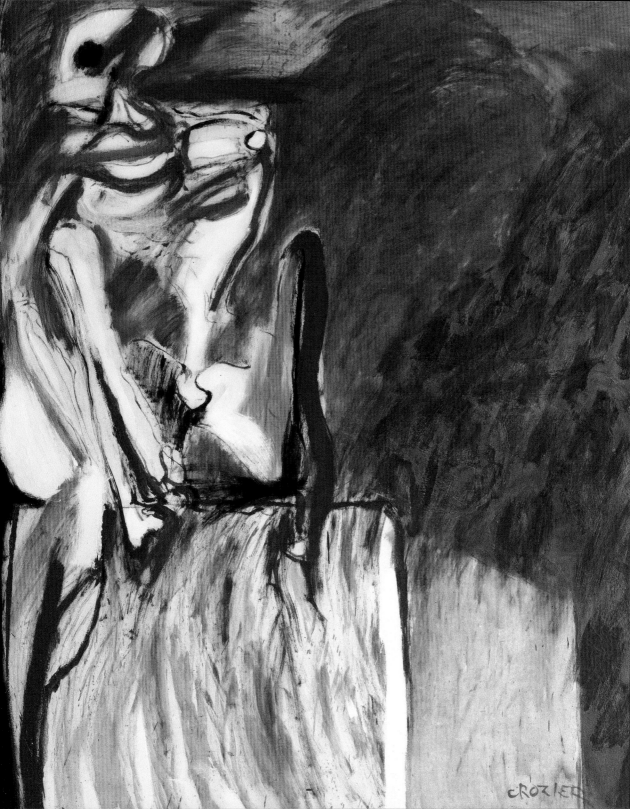

CROZIER

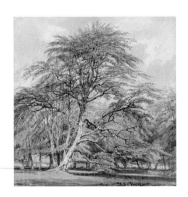

25 Monday · Luan

26 Tuesday · Máirt

27 Wednesday · Céadaoin

28 Thursday · Déardaoin

29 Friday · Aoine

30 Saturday · Satharn

1 Sunday · Domhnach May · Bealtaine

Joseph Mallord William Turner, *Beech Trees at Norbury Park, Surrey,* **c.1797**

In 1797, the young Turner visited Norbury Park in Surrey, home of the sculptor, collector and patron of the arts William Locke, who commissioned him to paint a view of the fernhouse at his demesne. While working there, Turner made detailed studies of the great beech trees on the estate. In this watercolour he captures their graceful branches and delicate foliage in a light, feathery technique. This reveals the sensitivity of brushwork that begins to appear in Turner's work around this date, when his confidence at depicting nature was growing.

M	T	W	T	F	S	S
28	29	30	31	1	2	3
4	5	6	7	8	9	10
11	12	13	14	15	16	17
18	19	20	21	22	23	24
25	26	27	28	29	30	1

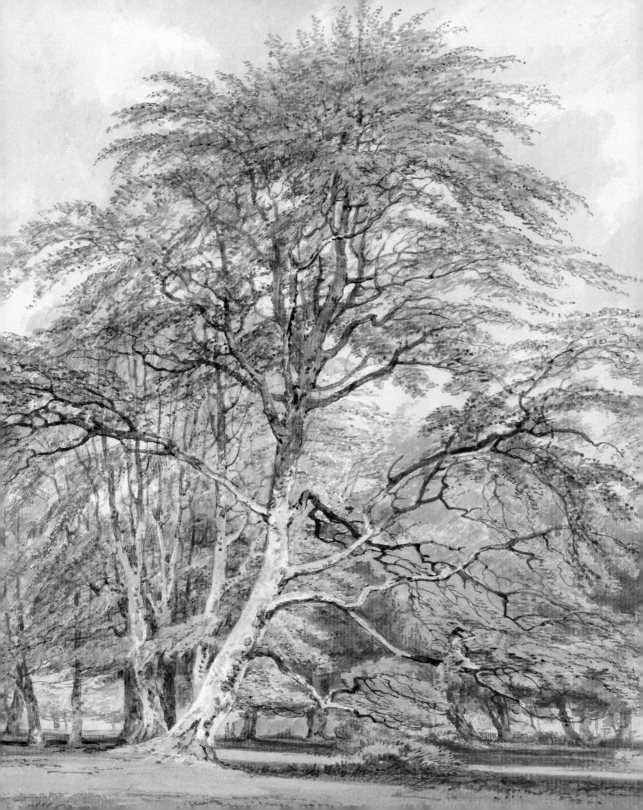

2 Monday · Luan
Bank Holiday (RoI and NI)

3 Tuesday · Máirt

4 Wednesday · Céadaoin

5 Thursday · Déardaoin

6 Friday · Aoine

7 Saturday · Satharn

8 Sunday · Domhnach

Moyra Barry, *Self-Portrait in the Artist's Studio,* **1920**

Moyra Barry produced still-life pictures, landscapes, genre scenes and portraits, but specialised in flower painting. In this spirited self-portrait, she adopts a serene, if somewhat quizzical expression as she looks up from her palette. She sports a short hairstyle and wears a black scarf, tied in a flat bow, high on her head in a manner that was highly fashionable in 1920. Her delicate facial features are carefully recorded, while her smock, palette and the studio in the background are realised with more expressive and vigorous brushwork, which shows the influence of Impressionism.

M	T	W	T	F	S	S
25	26	27	28	29	30	1
2	3	4	5	6	7	8
9	10	11	12	13	14	15
16	17	18	19	20	21	22
23	24	25	26	27	28	29
30	31	1	2	3	4	5

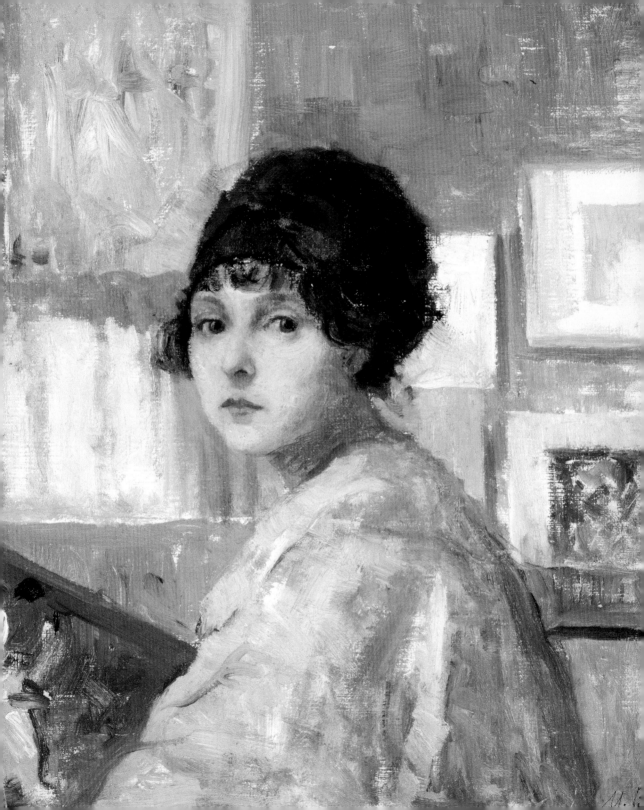

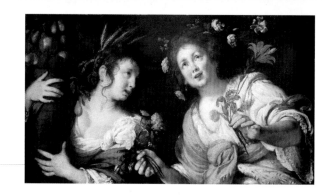

9 Monday · Luan

10 Tuesday · Máirt

11 Wednesday · Céadaoin

12 Thursday · Déardaoin

13 Friday · Aoine

14 Saturday · Satharn

15 Sunday · Domhnach

Bernardo Strozzi, *Allegory of Spring and Summer,* **late 1630s**

These female figures are personifications of Summer, on the left, and Spring, on the right, holding the attributes of their respective seasons. Summer carries a cornucopia of fruits and has sprigs of corn in her hair, while Spring holds various flowers in her hands and more blossoms decorate her hair. Strozzi hailed from Genoa, later settling in Venice, where fruit and corn both ripen in summer, much earlier in the year than in Britain and Ireland. This painting dates from the final period of his career, when Strozzi's use of delicate Venetian colouring and light and rich impasto became looser.

M	T	W	T	F	S	S
25	26	27	28	29	30	1
2	3	4	5	6	7	8
9	10	11	12	13	14	15
16	17	18	19	20	21	22
23	24	25	26	27	28	29
30	31	1	2	3	4	5

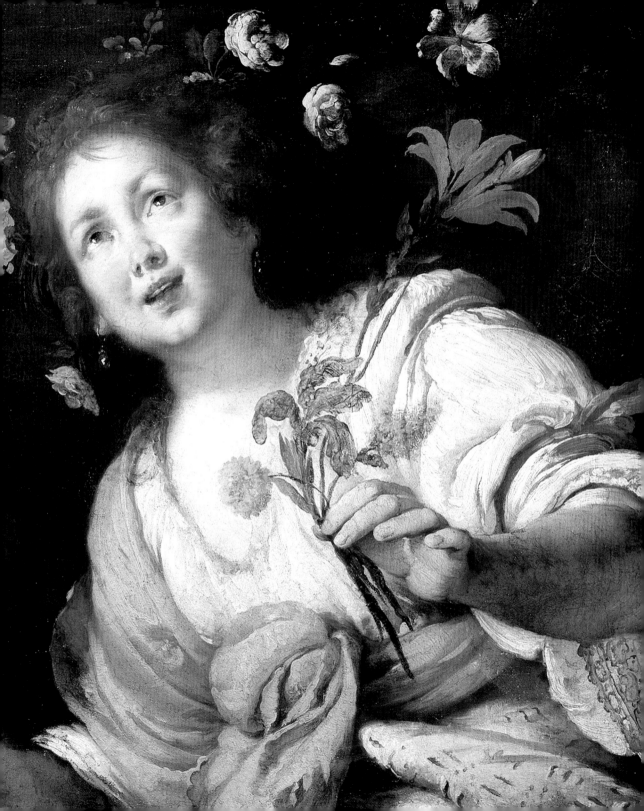

16 Monday • Luan

17 Tuesday • Máirt

18 Wednesday • Céadaoin

19 Thursday • Déardaoin

20 Friday • Aoine

21 Saturday • Satharn

22 Sunday • Domhnach

Walter Osborne, *Portrait of John William Scharff,* **c.1899**

Osborne established his successful portrait practice in Dublin in the early 1890s. He found formal portraiture tedious at times, but was happiest when painting children, whom he treated with sympathy, affection and understanding, while avoiding sentimentality. The sitter's father, Dr R. F. Scharff, came from Germany to work as a curator at the Natural History Museum in Dublin. His son John William was born in 1895 and is portrayed wearing a sailor suit, first made fashionable by the young Prince of Wales (later Edward VII). John William Scharff later became a specialist in tropical diseases and lectured in public health in Singapore.

M	T	W	T	F	S	S
25	26	27	28	29	30	1
2	3	4	5	6	7	8
9	10	11	12	13	14	15
16	17	18	19	20	21	22
23	24	25	26	27	28	29
30	31	1	2	3	4	5

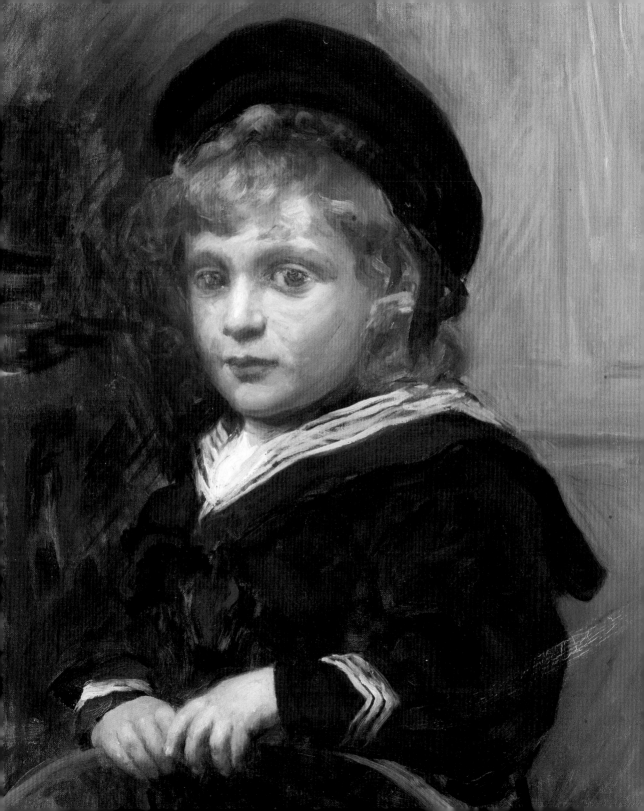

23 Monday • Luan

24 Tuesday • Máirt

25 Wednesday • Céadaoin

26 Thursday • Déardaoin

27 Friday • Aoine

28 Saturday • Satharn

29 Sunday • Domhnach

Augustus Burke, *A Connemara Girl,* **c.1880s**

This pretty young peasant girl has gathered heather in her apron, and may be on her way to have her two goats milked. The rugged terrain on which she stands barefoot is an accurate portrayal of the Connemara landscape. Burke was born in Co. Galway and, although he trained and worked as an artist in London and Brittany, he often turned for inspiration to the West of Ireland, painting its landscapes, animals and people.

M	T	W	T	F	S	S
25	26	27	28	29	30	1
2	3	4	5	6	7	8
9	10	11	12	13	14	15
16	17	18	19	20	21	22
23	24	25	26	27	28	29
30	31	1	2	3	4	5

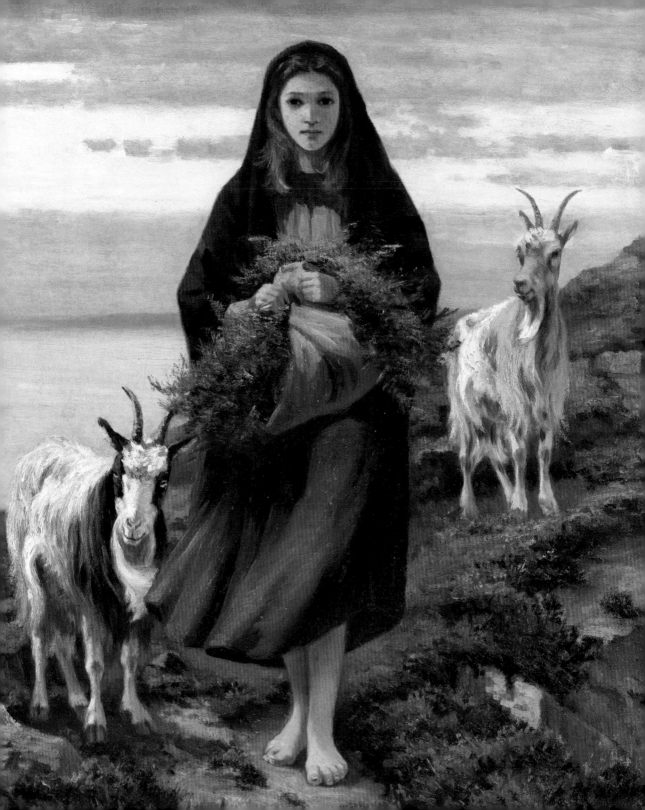

30 Monday • Luan

31 Tuesday • Máirt

1 Wednesday • Céadaoin June • Meitheamh

2 Thursday • Déardaoin

3 Friday • Aoine

4 Saturday • Satharn

5 Sunday • Domhnach

Maurice MacGonigal, *Fishing Fleet at Port Oriel, Clogherhead, Co. Louth,* **c.1940**

In the 1930s and 1940s, MacGonigal worked along the east coast, in counties Dublin and Louth, attracted by the harbours at Portmarnock, Rush and Port Oriel. The latter is a natural harbour north of Drogheda, in a sheltered position on a headland (Clogherhead). The fall of sunlight in this thickly painted, colourful scene indicates that it was captured in the afternoon. The composition leads the eye in a sweeping curve through the picture down to the fishermen preparing their nets and sails for work, while others watch from the quayside.

M	T	W	T	F	S	S
25	26	27	28	29	30	1
2	3	4	5	6	7	8
9	10	11	12	13	14	15
16	17	18	19	20	21	22
23	24	25	26	27	28	29
30	31	1	2	3	4	5

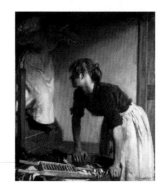

6 Monday • Luan
Bank Holiday (RoI)

7 Tuesday • Máirt

8 Wednesday • Céadaoin

9 Thursday • Déardaoin

10 Friday • Aoine

11 Saturday • Satharn

12 Sunday • Domhnach

William Orpen, *The Wash House,* **1905**

The model for this painting was Lottie Stafford, a cockney washerwoman who lived and worked in Paradise Walk, a slum neighbourhood in Chelsea, East London. She became one of Orpen's favourite models. Here she is captured pausing momentarily to look up from her washboard at a woman descending the stairs carrying laundry. Lottie's face is caught in profile while light falls on her neck, a feature that particularly appealed to Orpen. He records a washerwoman's arduous toil, but softens the image through the delicacy of his modelling.

M	T	W	T	F	S	S
30	31	1	2	3	4	5
6	7	8	9	10	11	12
13	14	15	16	17	18	19
20	21	22	23	24	25	26
27	28	29	30	1	2	3

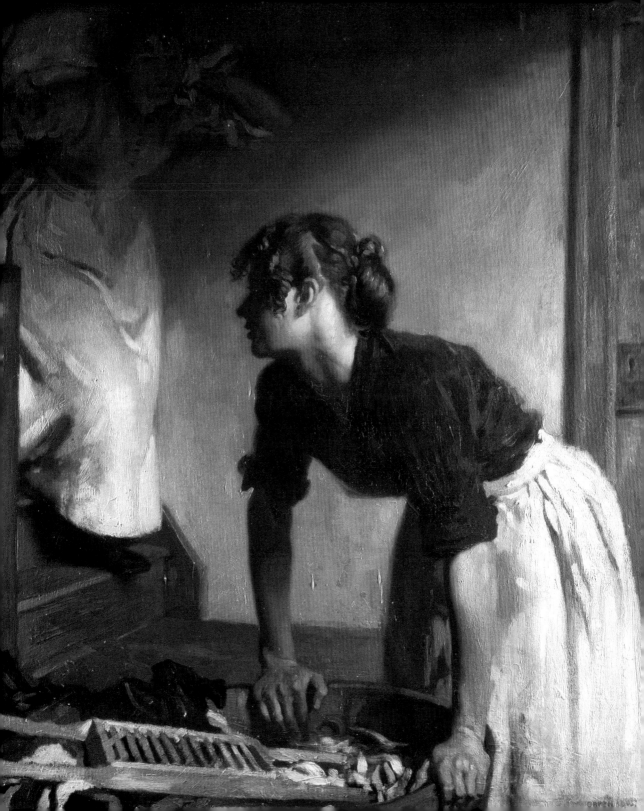

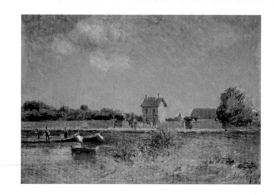

13 Monday · Luan

14 Tuesday · Máirt

15 Wednesday · Céadaoin

16 Thursday · Déardaoin

17 Friday · Aoine

18 Saturday · Satharn

19 Sunday · Domhnach

Alfred Sisley, *The Banks of the Canal du Loing at Saint-Mammès,* **1888**

Saint-Mammès lies at the confluence of the Seine and Loing rivers, with the canal running parallel to
the Loing. Sisley painted a series of views at Saint-Mammès, featuring the cluster of houses beside the
lock at the mouth of the canal. The expanse of sky is smooth, the buildings and colourful barges are
clearly delineated, while long, thick strokes of pigment are used to convey the reeds and foliage in the
foreground.

M	T	W	T	F	S	S
30	31	1	2	3	4	5
6	7	8	9	10	11	12
13	14	15	16	17	18	19
20	21	22	23	24	25	26
27	28	29	30	1	2	3

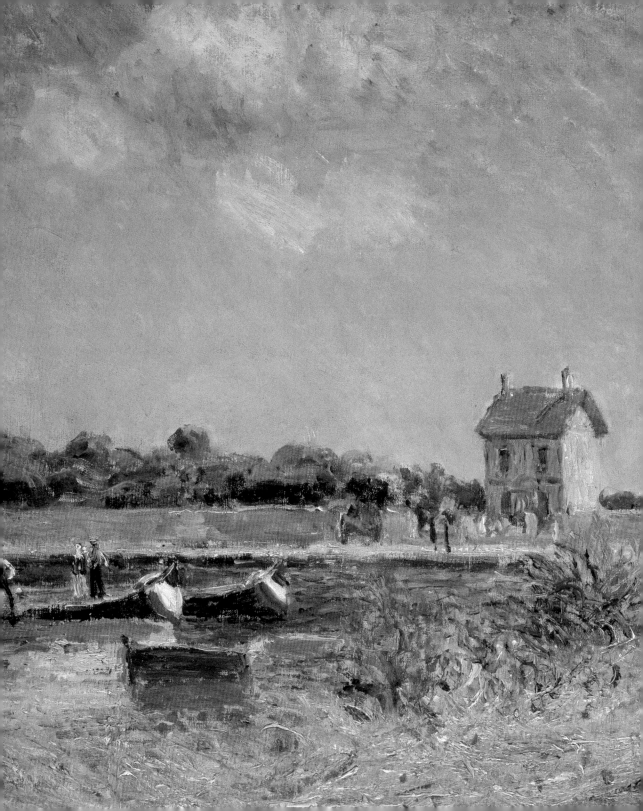

June • Meitheamh
Week 25 • Seachtain 25

20 Monday • Luan

21 Tuesday • Máirt

22 Wednesday • Céadaoin

23 Thursday • Déardaoin

24 Friday • Aoine

25 Saturday • Satharn

26 Sunday • Domhnach

Sarah Purser, *Portrait of Dr. Douglas Hyde (1860–1949), Poet, Scholar and First President of Ireland,* **1903**

Purser depicts Douglas Hyde holding an apple branch, symbolising his Gaelic pen name, *An Craoibhín Aoibhín* (the sweet little bough). The crimson apple is offset by his vivid red necktie, striped scarf and the russet background. Hyde studied law and theology at Trinity College Dublin before becoming a playwright, poet and scholar of Irish folklore, language and literature. He wrote plays for the Abbey Theatre and was co-founder and first President of the Gaelic League. He became Professor of Modern Irish language and literature at University College Dublin, a Senator of the Irish Free State, and the first President of Ireland.

M	T	W	T	F	S	S
30	31	1	2	3	4	5
6	7	8	9	10	11	12
13	14	15	16	17	18	19
20	21	22	23	24	25	26
27	28	29	30	1	2	3

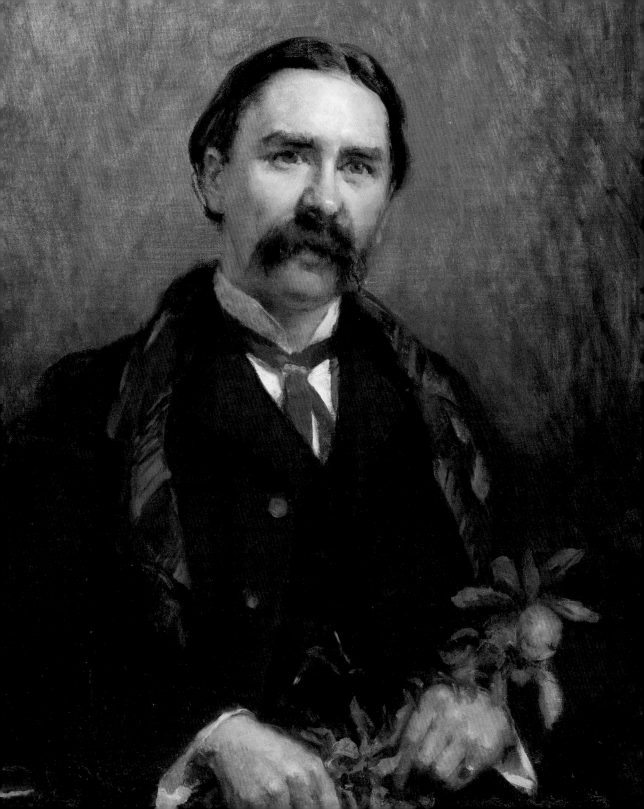

June · Meitheamh
Week 26 · Seachtain 26

27 Monday · Luan

28 Tuesday · Máirt

29 Wednesday · Céadaoin

30 Thursday · Déardaoin

1 Friday · Aoine July · Iúil

2 Saturday · Satharn

3 Sunday · Domhnach

Jean Bardon, *Annunciation Lilies,* **2008**

Graphic Studio Dublin was established in 1960 as the first fine art print studio in Ireland. In 2005 it approached the National Gallery with an idea, conceived by Jean Bardon, for a collaborative exhibition featuring prints by contemporary artists. The 29 participating artists were encouraged to look at the gallery's collection for inspiration. Known for her decorative, botanical-themed prints, Bardon's etching for the 2008 Revelation exhibition features lilies and gold leaf, both of which recur in many of the gallery's Medieval and Early Renaissance religious paintings, especially those portraying the Madonna.

M	T	W	T	F	S	S
30	31	1	2	3	4	5
6	7	8	9	10	11	12
13	14	15	16	17	18	19
20	21	22	23	24	25	26
27	28	29	30	1	2	3

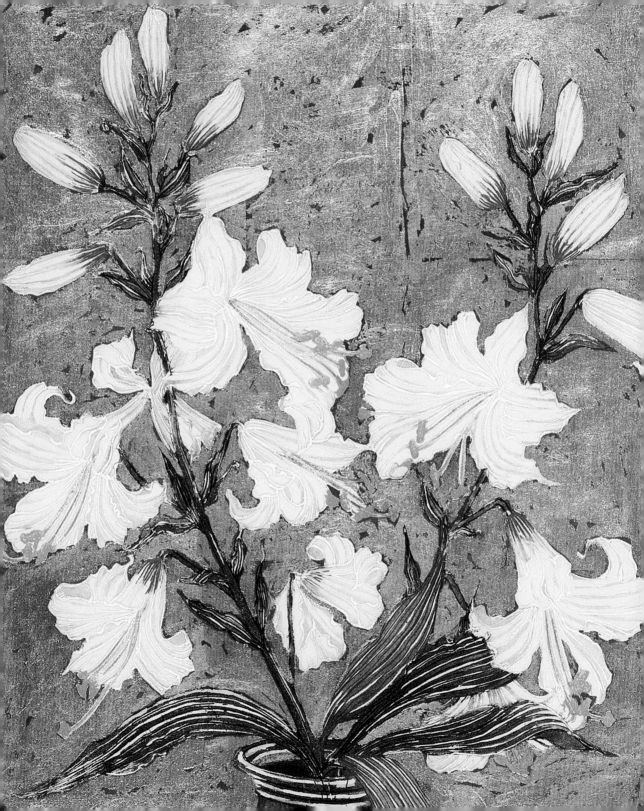

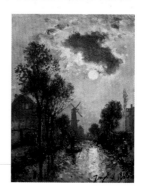

4 Monday · Luan

5 Tuesday · Máirt

6 Wednesday · Céadaoin

7 Thursday · Déardaoin

8 Friday · Aoine

9 Saturday · Satharn

10 Sunday · Domhnach

Johan Barthold Jongkind, *A Windmill in Moonlight,* **1868**

During the 1860s, a time when he was influenced by and conversed with the future French Impressionists, Jongkind gained a reputation for nocturnal landscapes lit by the pale beams of a full moon. Here, the moon emerges from clouds to cast its light on the surface of a shimmering canal. The painting's vertical format is echoed by the trees, the silhouette of the windmill and the standing figure of a man in his small boat.

M	T	W	T	F	S	S
27	28	29	30	1	2	3
4	5	6	7	8	9	10
11	12	13	14	15	16	17
18	19	20	21	22	23	24
25	26	27	28	29	30	31

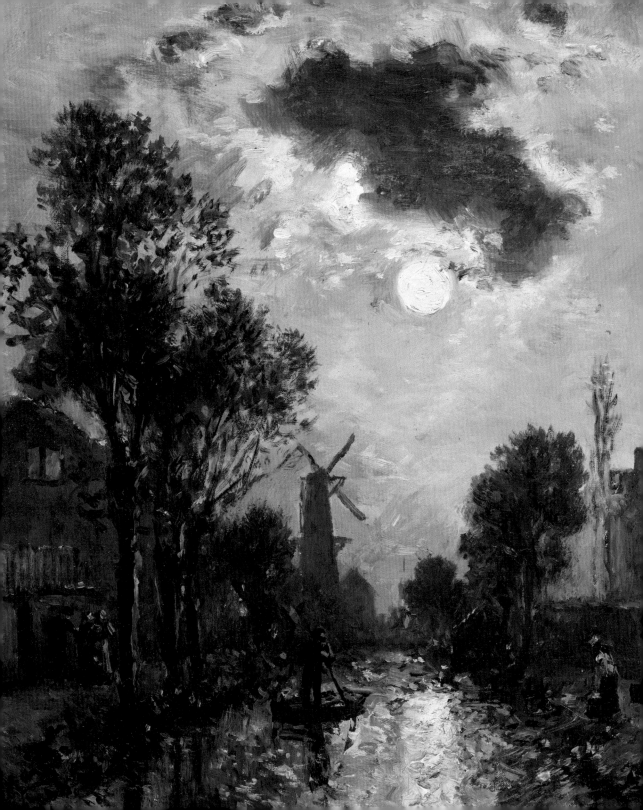

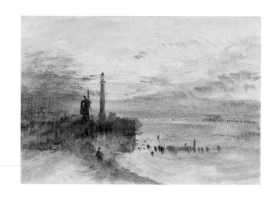

11 Monday · Luan

12 Tuesday · Máirt

13 Wednesday · Céadaoin

14 Thursday · Déardaoin

15 Friday · Aoine

16 Saturday · Satharn

17 Sunday · Domhnach

Joseph Mallord William Turner, *Ostend Harbour,* **c.1840**

A solitary figure contemplates a spectacular sunset whose intense colours render the lighthouse, windmill and walled structure below less dominant. The location of this scene has recently been identified as Ostend Harbour in Belgium, which Turner visited on his journey home from Venice in 1840. During the 1840s he produced many watercolours of beaches and skies using loose, fluid washes in which he captured the overall impression of fiery sunsets rather than creating accurate topographical records. Most of these seem to have been made for his own satisfaction rather than as preparatory studies for more finished pictures.

M	T	W	T	F	S	S
27	28	29	30	1	2	3
4	5	6	7	8	9	10
11	12	13	14	15	16	17
18	19	20	21	22	23	24
25	26	27	28	29	30	31

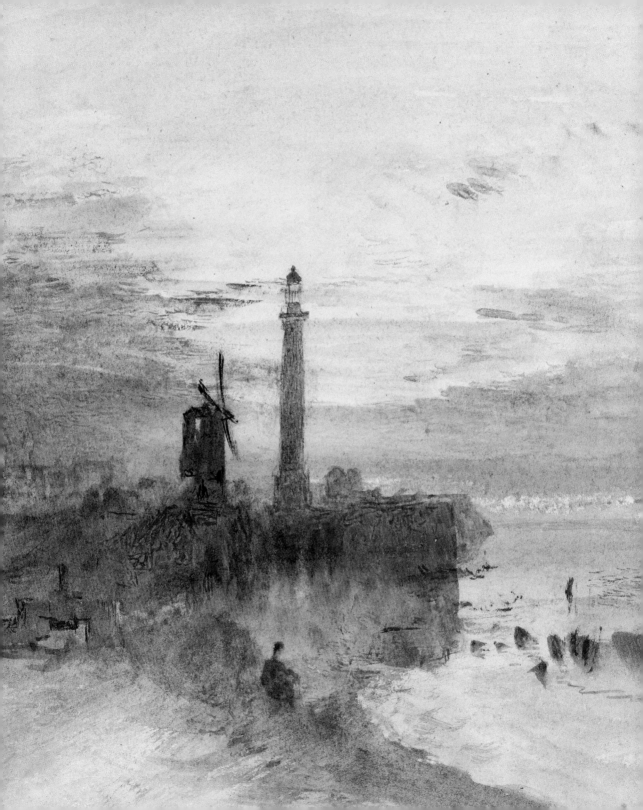

July · Iúil
Week 29 · Seachtain 29

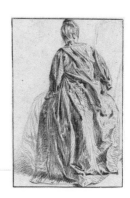

18 Monday · Luan

19 Tuesday · Máirt

20 Wednesday · Céadaoin

21 Thursday · Déardaoin

22 Friday · Aoine

23 Saturday · Satharn

24 Sunday · Domhnach

Jean-Antoine Watteau, *Woman seen from the back,* **c.1715–1716**
Watteau is regarded as one of the greatest draughtsmen in the history of European art. He was a master of the technique known as *aux trois crayons*, a combination of red, black and white chalks. Most of Watteau's drawings are figure studies. He was particularly intrigued by figures seen from the back. They occur frequently in his work, often as solitary figures detached from the main group, as in this beautiful drawing of a woman.

M	T	W	T	F	S	S
27	28	29	30	1	2	3
4	5	6	7	8	9	10
11	12	13	14	15	16	17
18	19	20	21	22	23	24
25	26	27	28	29	30	31

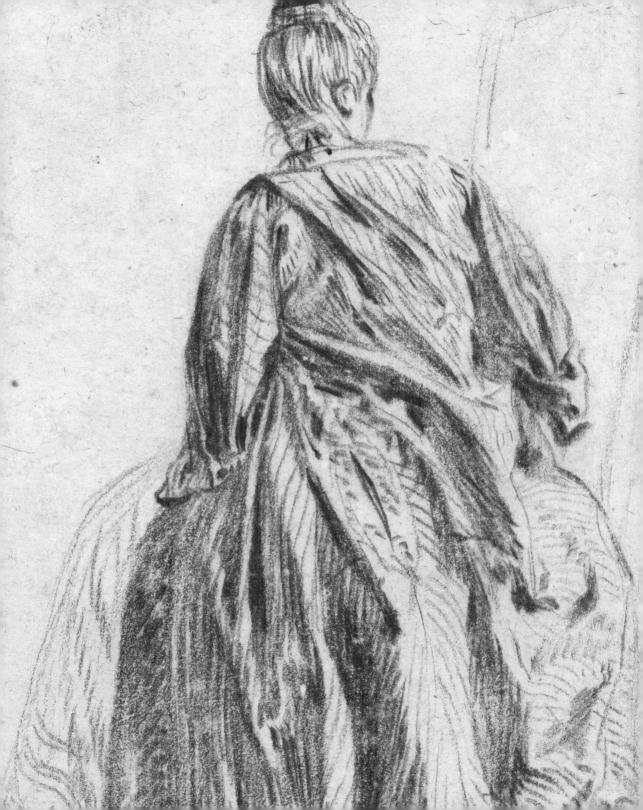

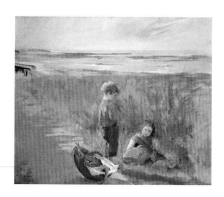

25 Monday · Luan

26 Tuesday · Máirt

27 Wednesday · Céadaoin

28 Thursday · Déardaoin

29 Friday · Aoine

30 Saturday · Satharn

31 Sunday · Domhnach

Eva Gonzalès, *Children on the Sand Dunes, Grandcamp,* **1877–78**

Under the influence of Édouard Manet, Eva Gonzalès embraced painting *en plein air* (in the open air).
Grandchamp, a seaside resort in northern Brittany, was accessible by train from Paris and Gonzalès
holidayed there in 1877-78, painting several landscapes on site. These children, having collected fish at
market, have stopped on their return to play at the edge of the grassy sand dunes. Colour is concentrated
on their clothing, hair and their basket of fish. The light palette and broad, rapid brushstrokes reveal the
artist's freedom of expression.

M	T	W	T	F	S	S
27	28	29	30	1	2	3
4	5	6	7	8	9	10
11	12	13	14	15	16	17
18	19	20	21	22	23	24
25	26	27	28	29	30	31

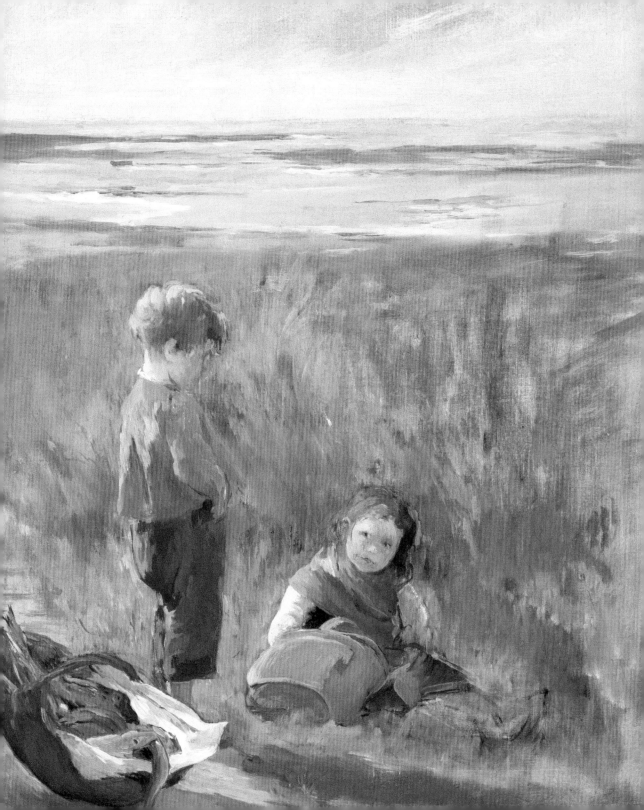

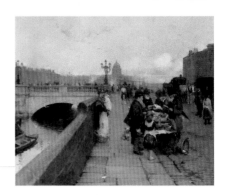

1 Monday · Luan
Bank Holiday (RoI)

2 Tuesday · Máirt

3 Wednesday · Céadaoin

4 Thursday · Déardaoin

5 Friday · Aoine

6 Saturday · Satharn

7 Sunday · Domhnach

Walter Osborne, *The Dublin Streets: A Vendor of Books,* **1889**

A bookseller plies his trade as potential customers crowd around his stall, watched by a flower seller and her children. They are gathered on Aston Quay in Dublin city, close to O'Connell Bridge, with the Custom House visible in the background. Osborne's adoption of *plein air* painting, his treatment of light, his loose brushstrokes and his celebration of everyday urban subjects are all evident in this detailed work.

M	T	W	T	F	S	S
1	2	3	4	5	6	7
8	9	10	11	12	13	14
15	16	17	18	19	20	21
22	23	24	25	26	27	28
29	30	31	1	2	3	4

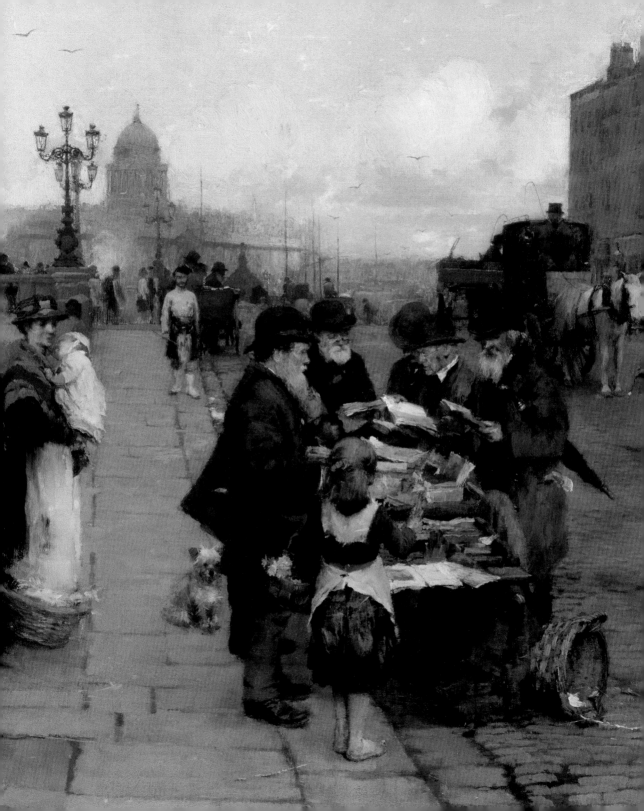

August · Lúnasa
Week 32 · Seachtain 32

8 Monday · Luan

9 Tuesday · Máirt

10 Wednesday · Céadaoin

11 Thursday · Déardaoin

12 Friday · Aoine

13 Saturday · Satharn

14 Sunday · Domhnach

Casimir Dunin Markievicz, *The Artist's Wife, Constance, Comtesse de Markievicz (1868–1927),*
Irish Painter and Revolutionary, **1899**

Constance Gore-Booth grew up at Lissadell, Co. Sligo, and studied art in London and in Paris, where she
met Count Dunin Markievicz, a Polish aristocrat and artist. He painted this portrait in the year before their
marriage, capturing Constance's elegant beauty and stature in a painting which belies her future career. In
1908 she plunged herself into nationalist politics, campaigning for the freedom of Ireland, the emancipation
of workers and the vote for women. She joined the Irish Citizen Army, carrying arms in the Easter Rising.

M	T	W	T	F	S	S
1	2	3	4	5	6	7
8	9	10	11	12	13	14
15	16	17	18	19	20	21
22	23	24	25	26	27	28
29	30	31	1	2	3	4

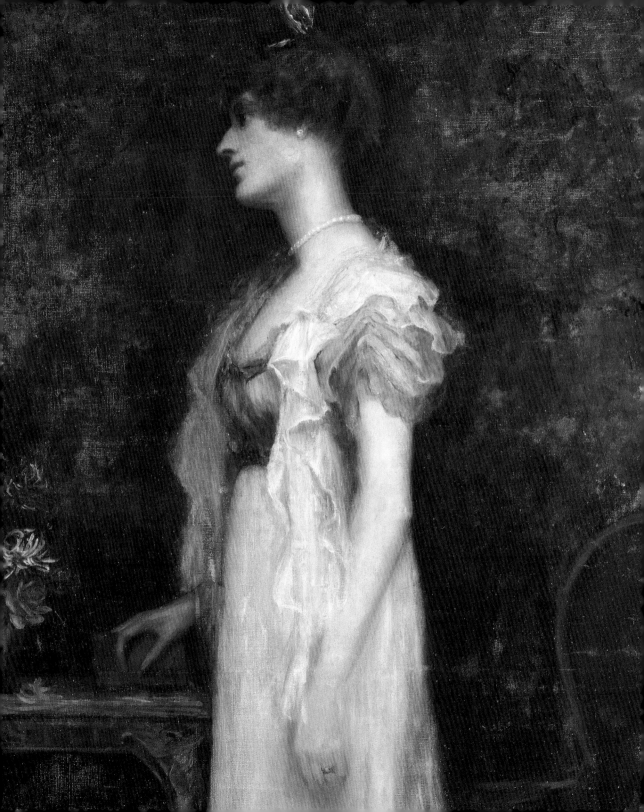

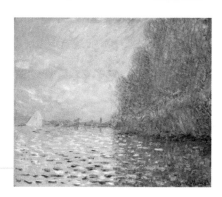

August · Lúnasa
Week 33 · Seachtain 33

15 Monday · Luan

16 Tuesday · Máirt

17 Wednesday · Céadaoin

18 Thursday · Déardaoin

19 Friday · Aoine

20 Saturday · Satharn

21 Sunday · Domhnach

Claude Monet, *Argenteuil Basin with a Single Sailboat,* **1874**

Argenteuil, a picturesque town and Parisian suburb, can be glimpsed on the horizon, near a single yacht. In the 19th century it was popular for Sunday trips and pleasure boating as it was on the banks of the river Seine and on the train line between Paris and Rouen. Monet acquired a boat which he fitted out as a floating studio, and worked rapidly to capture the fleeting effects of light reflecting on the water's surface.

M	T	W	T	F	S	S
1	2	3	4	5	6	7
8	9	10	11	12	13	14
15	16	17	18	19	20	21
22	23	24	25	26	27	28
29	30	31	1	2	3	4

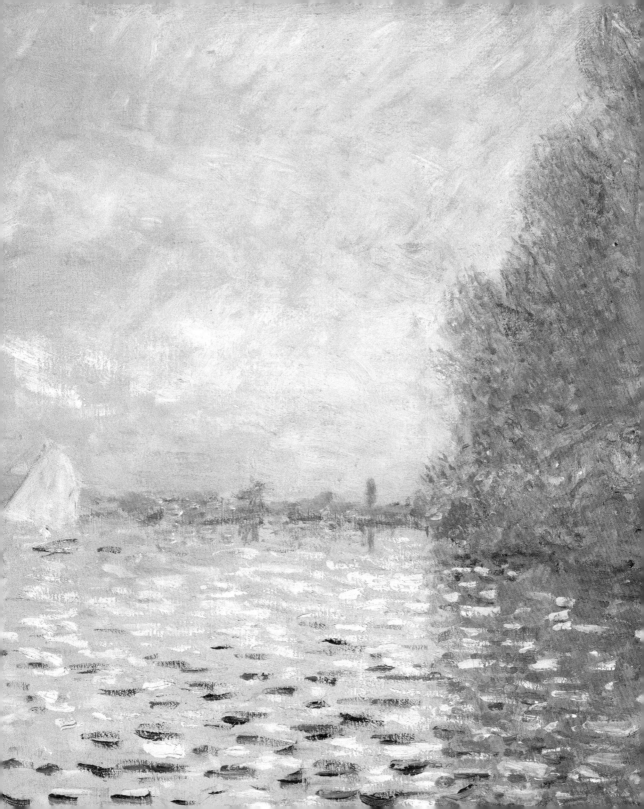

22 Monday · Luan

23 Tuesday · Máirt

24 Wednesday · Céadaoin

25 Thursday · Déardaoin

26 Friday · Aoine

27 Saturday · Satharn

28 Sunday · Domhnach

Frederic William Burton, *Cassandra Fedele, Poet and Musician,* **1869**

Cassandra Fedele, the famed Venetian scholar, poet, orator and musician, debated in the late 15th century with leading humanists on philosophy and theology and was outspoken on the subject of higher education for women. Her importance as muse of Venice is indicated by her laurel wreath, symbolic of triumph, as she fingers her viol before a music stand. Fedele's beauty and grace are drawn by Burton with skilful delicacy in a work revealing the influence of the English Pre-Raphaelite painters: Cassandra's costume is loosely inspired by Renaissance dress. Behind her, curtained bookshelves are flanked by the figures of St George and St Sebastian.

M	T	W	T	F	S	S
1	2	3	4	5	6	7
8	9	10	11	12	13	14
15	16	17	18	19	20	21
22	23	24	25	26	27	28
29	30	31	1	2	3	4

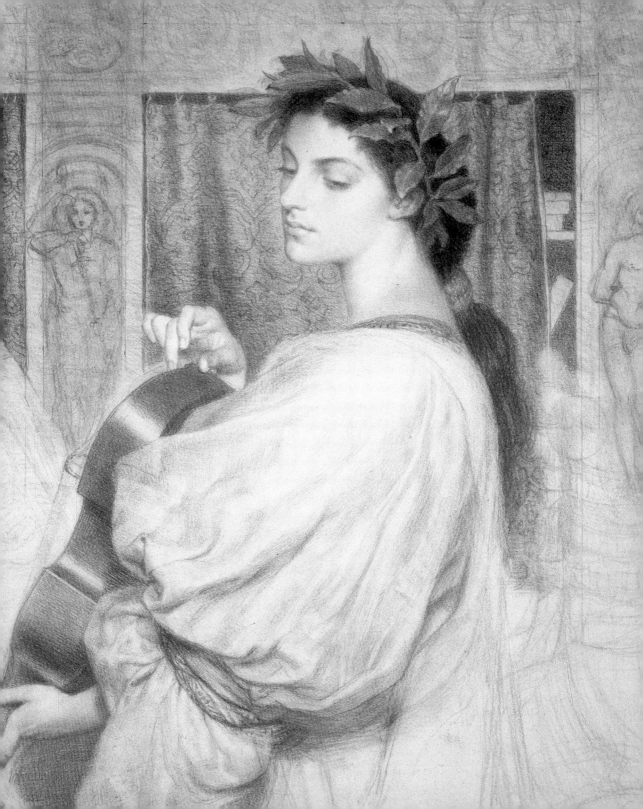

August · Lúnasa
Week 35 · Seachtain 35

29 Monday · Luan

30 Tuesday · Máirt

31 Wednesday · Céadaoin

1 Thursday · Déardaoin September · Meán Fómhair

2 Friday · Aoine

3 Saturday · Satharn

4 Sunday · Domhnach

Walter Osborne, *By the Sea,* **c.1900**

Osborne was, with Nathaniel Hone the Younger, the most important Irish artist in the introduction of
French Naturalism to Ireland. Osborne painted North County Dublin landscapes including beach and pasture
scenes similar to Hone's, working *en plein air* (in the open air) in the seaside towns of Rush, Malahide and
Portmarnock. Osborne brought his technique to a highly impressionistic level in his late works, such as
By the Sea. In this loosely handled watercolour, the figures of the women and children are captured with
economy as they engage in paddling or, perhaps, rock-pooling.

M	T	W	T	F	S	S
1	2	3	4	5	6	7
8	9	10	11	12	13	14
15	16	17	18	19	20	21
22	23	24	25	26	27	28
29	30	31	1	2	3	4

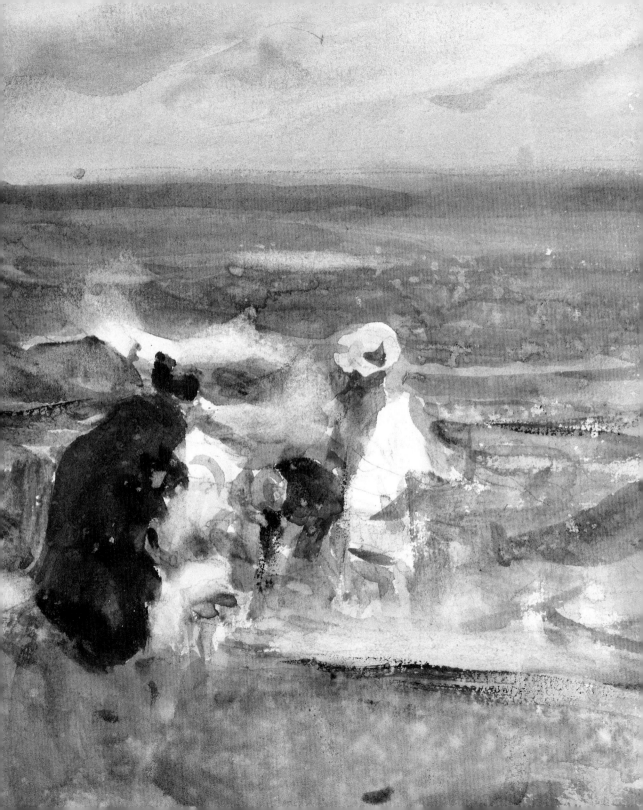

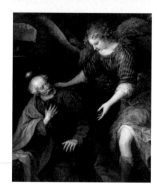

5 Monday · Luan

6 Tuesday · Máirt

7 Wednesday · Céadaoin

8 Thursday · Déardaoin

9 Friday · Aoine

10 Saturday · Satharn

11 Sunday · Domhnach

José Antolínez, *The Liberation of Saint Peter,* **early 1670s**

King Herod Agrippa arrested and imprisoned St Peter in Jerusalem for his preaching. He was bound with heavy chains and guarded by soldiers, but during the night an angel liberated him. The angel is shown waking Peter, whose chains fall from his hands. He tries to rise from his knees as he looks up at the vision with tears in his eyes. The angel's striped tunic and billowing drapery are rendered in the characteristic bright hues of Antolínez, who often combined the Venetian colouring of Titian with the swirling Baroque compositions of Rubens.

M	T	W	T	F	S	S
29	30	31	1	2	3	4
5	6	7	8	9	10	11
12	13	14	15	16	17	18
'19	20	21	22	23	24	25
26	27	28	29	30	1	2

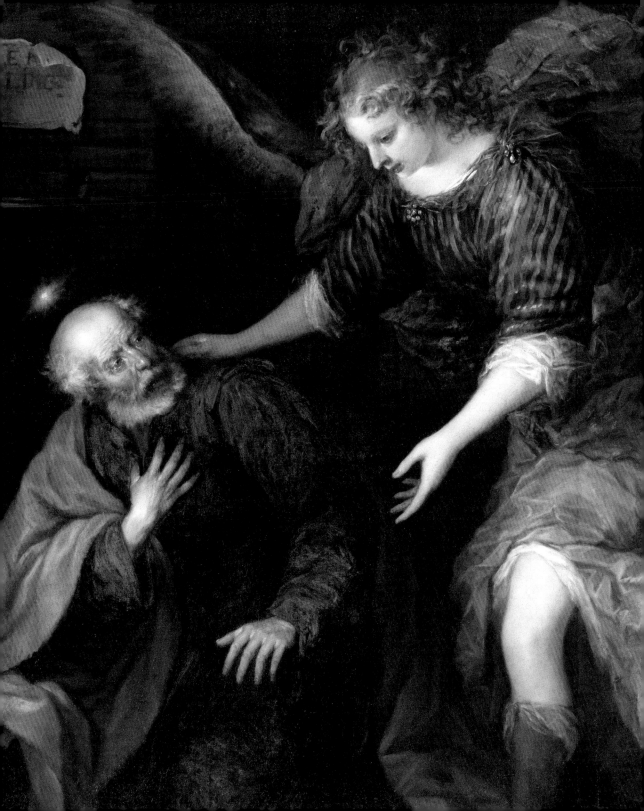

12 Monday · Luan

13 Tuesday · Máirt

14 Wednesday · Céadaoin

15 Thursday · Déardaoin

16 Friday · Aoine

17 Saturday · Satharn

18 Sunday · Domhnach

Harry Clarke, *The Shepherdess and the Chimney Sweeper,* **1916**

One of Hans Christian Andersen's fairy tales, this story tells of a romance between two porcelain figurines, a shepherdess and a chimney sweep. Their romance is threatened, however, by a larger porcelain Chinaman, shown in vivid reds and greens behind them, who tries to force the shepherdess to marry a carved satyr. The lovers escape to the rooftop, where the shepherdess gazes upon the vast world and takes fright. They return to discover that the Chinaman, in his pursuit, has fallen and broken to pieces. The lovers are safe at last.

M	T	W	T	F	S	S
29	30	31	1	2	3	4
5	6	7	8	9	10	11
12	13	14	15	16	17	18
19	20	21	22	23	24	25
26	27	28	29	30	1	2

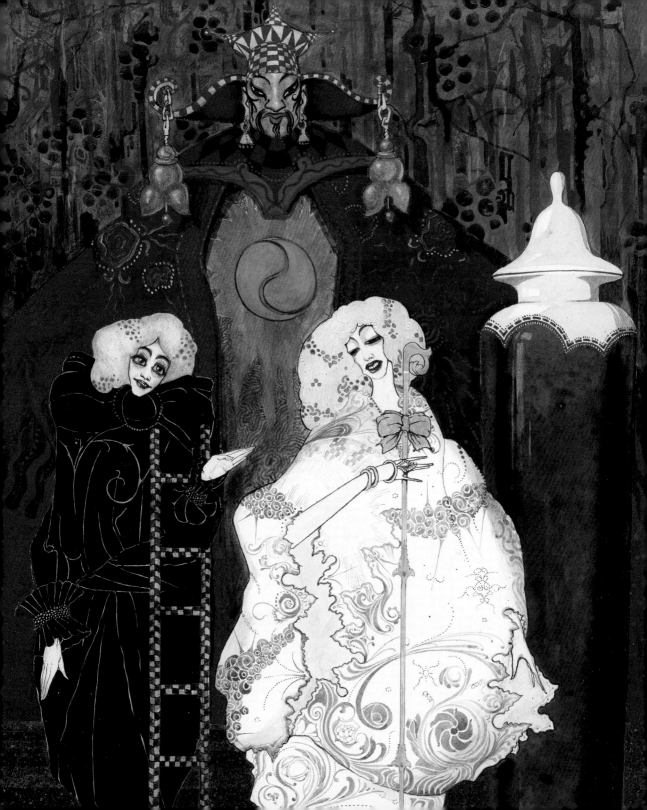

19 Monday · Luan

20 Tuesday · Máirt

21 Wednesday · Céadaoin

22 Thursday · Déardaoin

23 Friday · Aoine

24 Saturday · Satharn

25 Sunday · Domhnach

Vincent van Gogh, *Rooftops in Paris,* **1886**

In early 1886 Vincent van Gogh travelled from his native Holland to Paris, where he rented an apartment with his brother Theo on the Rue Lepic near Montmartre. This bohemian district of Paris afforded panoramic views of the city, and from his window, Vincent painted four views of the rooftops. This painting, one of that series, shows the city centre extending south. The thick application of paint evokes a cloudy, overcast sky.

M	T	W	T	F	S	S
29	30	31	1	2	3	4
5	6	7	8	9	10	11
12	13	14	15	16	17	18
19	20	21	22	23	24	25
26	27	28	29	30	1	2

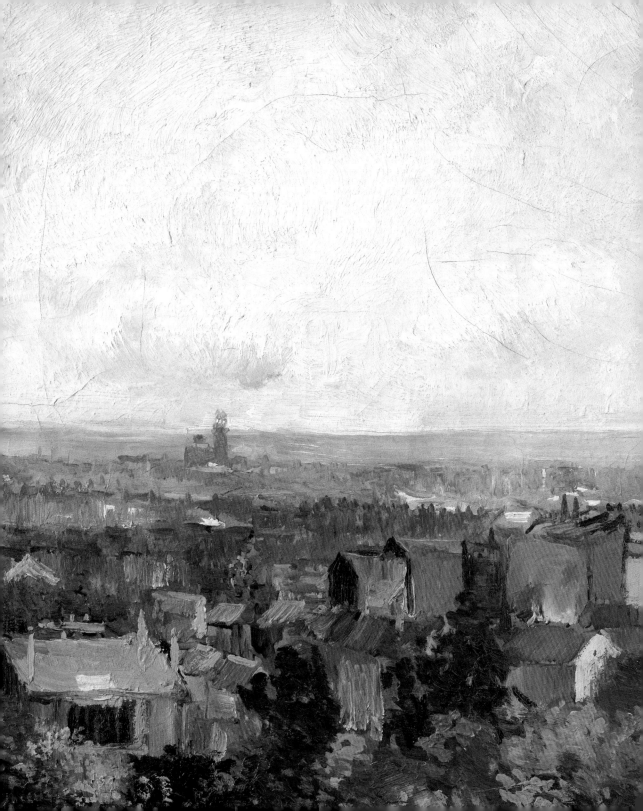

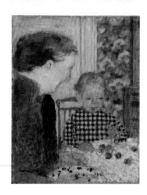

26 Monday · Luan

27 Tuesday · Máirt

28 Wednesday · Céadaoin

29 Thursday · Déardaoin

30 Friday · Aoine

1 Saturday · Satharn October · Deireadh Fómhair

2 Sunday · Domhnach

Pierre Bonnard, *Boy Eating Cherries,* **1895**

During the 1890s Bonnard spent many summers at his grandmother's house in the Dauphiné province
of France, where he recorded quiet family scenes and domestic interiors in a style that became known
as Intimist. Here, Bonnard's nephew Jean tucks into his cherries while his grandmother watches.
Influenced by Japanese woodblock prints, Bonnard explored the decorative potential of flat patterns,
seen here in Jean's blue and white checked shirt, which competes for our attention with the floral
wallpaper behind him.

M	T	W	T	F	S	S
29	30	31	1	2	3	4
5	6	7	8	9	10	11
12	13	14	15	16	17	18
19	20	21	22	23	24	25
26	27	28	29	30	1	2

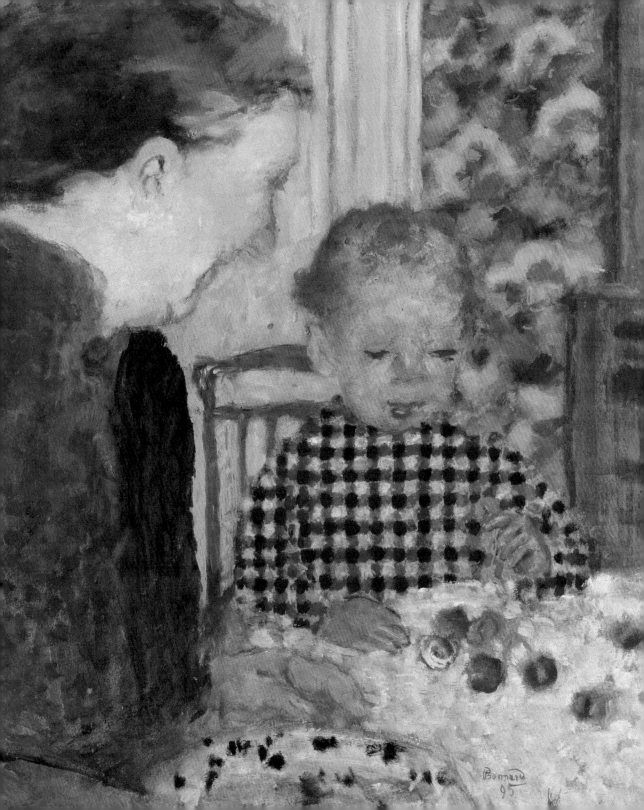

October · Deireadh Fómhair
Week 40 · Seachtain 40

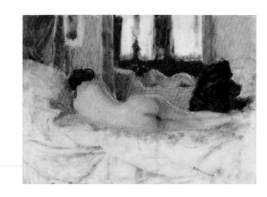

3 Monday · Luan

4 Tuesday · Máirt

5 Wednesday · Céadaoin

6 Thursday · Déardaoin

7 Friday · Aoine

8 Saturday · Satharn

9 Sunday · Domhnach

Roderic O'Conor, *Reclining Nude before a Mirror,* **1909**

O'Conor made a study of the work of the Spanish painter Velázquez, whose *Rokeby Venus*, a sophisticated back view of a woman reclining before a mirror, inspired this sensitive sketch. Natural light falls on the nude's body, giving it a soft illumination, and in his warm colours, his use of the mirror and his Intimist treatment of the subject, O'Conor was influenced by the French painter Bonnard. The canvas has been lightly stained, the oil paint thinned down to give a transparent wash against which more intense colours were applied.

M	T	W	T	F	S	S
26	27	28	29	30	1	2
3	4	5	6	7	8	9
10	11	12	13	14	15	16
17	18	19	20	21	22	23
24	25	26	27	28	29	30
31	1	2	3	4	5	6

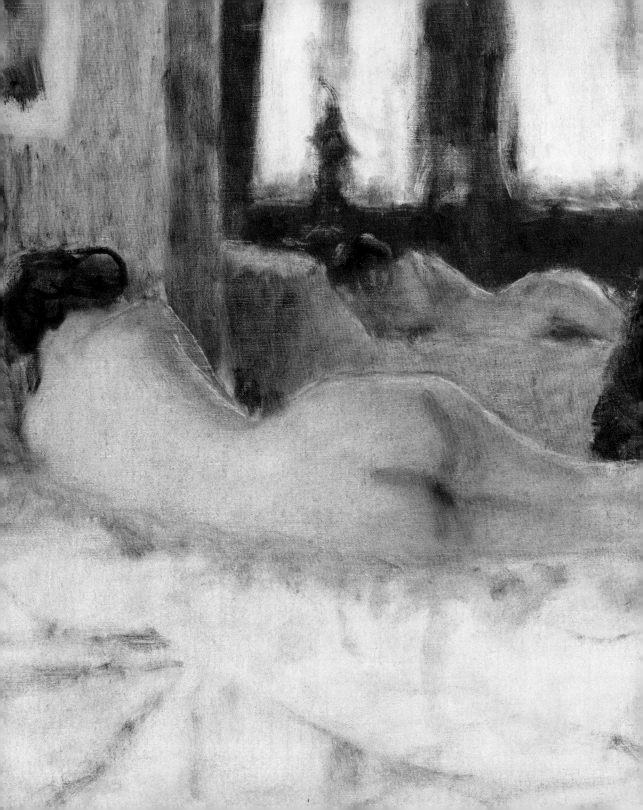

10 Monday · Luan

11 Tuesday · Máirt

12 Wednesday · Céadaoin

13 Thursday · Déardaoin

14 Friday · Aoine

15 Saturday · Satharn

16 Sunday · Domhnach

Sarah Purser, *A Lady Holding a Doll's Rattle,* **1885**

The Irish woman holding a rattle, Mary Maud de la Poer Beresford, was the daughter of Colonel Marcus de la Poer Beresford. She was the wife of the novelist Julian Sturgis. Sarah Purser spent the late summer of 1885 with Mary and Julian in Surrey, producing seven pictures of them. An inscription at the bottom of this canvas indicates that Purser dedicated the work to Julian Sturgis. It is a lively sketch, painted with a confidence and economy that recalls Purser's time in Paris and suggests the influence of Impressionism.

M	T	W	T	F	S	S
26	27	28	29	30	1	2
3	4	5	6	7	8	9
10	11	12	13	14	15	16
17	18	19	20	21	22	23
24	25	26	27	28	29	30
31	1	2	3	4	5	6

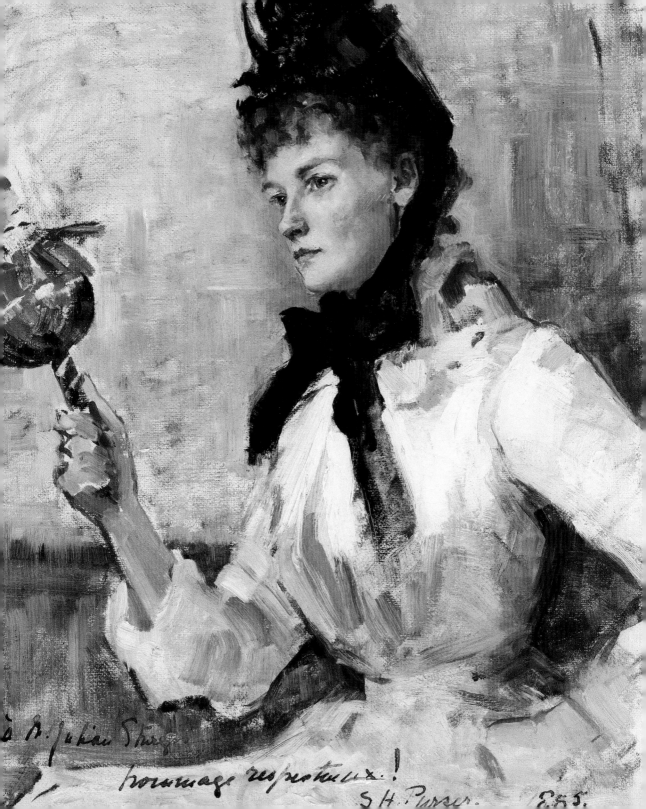

à B. Julian Sturge

hommage respectueux!

S.H. Purser. E.5.

17 Monday · Luan

18 Tuesday · Máirt

19 Wednesday · Céadaoin

20 Thursday · Déardaoin

21 Friday · Aoine

22 Saturday · Satharn

23 Sunday · Domhnach

Frans Hals, *The Lute Player,* **1630s**

In Haarlem, Frans Hals specialised in life-sized portraits of figures drinking or making music, a theme which is particularly associated with the Dutch followers of Caravaggio. As this fashionably dressed man plays his lute, he turns towards the viewer with an engaging glance. The obvious pentimento in the contour of his hat indicates the artist's change of mind about its shape and position. Despite receiving important portrait commissions throughout his career, Hals was frequently in financial difficulties.

M	T	W	T	F	S	S
26	27	28	29	30	1	2
3	4	5	6	7	8	9
10	11	12	13	14	15	16
17	18	19	20	21	22	23
24	25	26	27	28	29	30
31	1	2	3	4	5	6

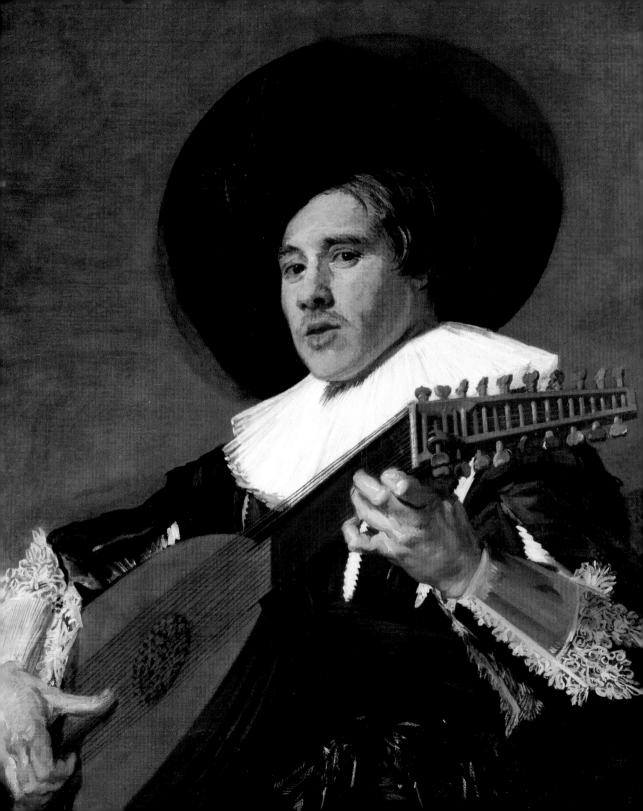

October · Deireadh Fómhair
Week 43 · Seachtain 43

24 Monday · Luan

25 Tuesday · Máirt

26 Wednesday · Céadaoin

27 Thursday · Déardaoin

28 Friday · Aoine

29 Saturday · Satharn

30 Sunday · Domhnach

Anton Mauve, *Shepherd and Sheep,* **1885–88**

The Dutch artist Anton Mauve initially specialised in painting animals, followed by simple rural subjects created under the influence of French Barbizon painters Millet and Corot. Mauve became a member of the Hague School and moved to Laren, the Dutch Barbizon, where he concentrated on painting landscape and village scenes, as well as beach scenes created at Scheveningen, on the coast. *Shepherd and Sheep* is typical of his later work in Laaren, when figures acquired an increased importance in compositions, which he built up in thin layers of grey tones, with distinct touches of colour to bring out the details.

M	T	W	T	F	S	S
26	27	28	29	30	1	2
3	4	5	6	7	8	9
10	11	12	13	14	15	16
17	18	19	20	21	22	23
24	25	26	27	28	29	30
31	1	2	3	4	5	6

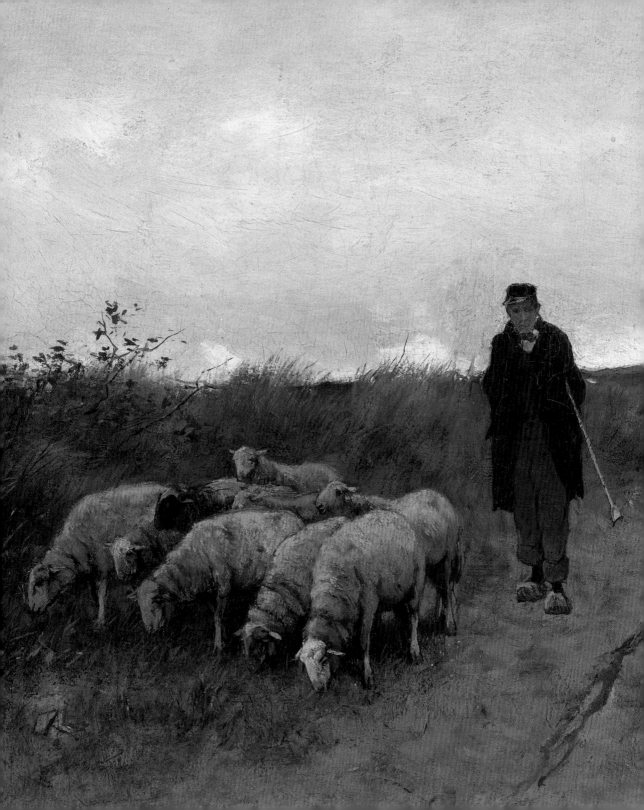

31 Monday · Luan
Bank Holiday (RoI)

1 Tuesday · Máirt November · Samhain

2 Wednesday · Céadaoin

3 Thursday · Déardaoin

4 Friday · Aoine

5 Saturday · Satharn

6 Sunday · Domhnach

Matthew James Lawless, *A Sick Call,* **1863**

A grave-looking priest, accompanied by a similarly sombre party, crosses a river to administer the Last Rites to a dying person. The picture, one of a small number of recognised works by the artist, reflects Lawless's admiration for earlier 19th-century French painting, but also his knowledge of Dutch 17th-century art, while the architectural detail and setting were inspired by his travels in northern Europe and, perhaps, a drawing of Prague that he had admired. The subject itself is best understood in the context of Lawless's own persistent ill health.

M	T	W	T	F	S	S
26	27	28	29	30	1	2
3	4	5	6	7	8	9
10	11	12	13	14	15	16
17	18	19	20	21	22	23
24	25	26	27	28	29	30
31	1	2	3	4	5	6

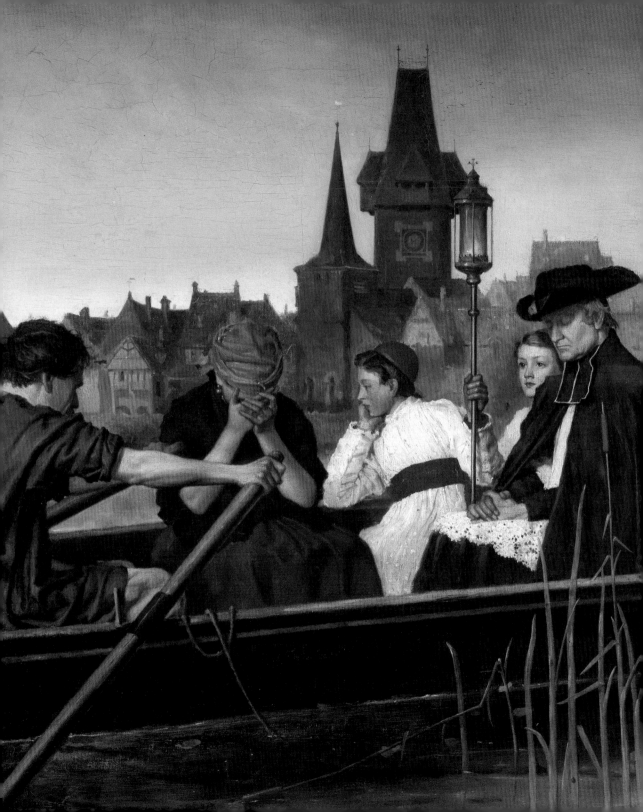

November · Samhain
Week 45 · Seachtain 45

7 Monday · Luan

8 Tuesday · Máirt

9 Wednesday · Céadaoin

10 Thursday · Déardaoin

11 Friday · Aoine

12 Saturday · Satharn

13 Sunday · Domhnach

John Lavery, *Portrait of John Stewart Collis (1900–1984), Author,* **1940**

In 1938, following his tour of Hollywood, Palm Springs and Florida, Lavery returned to England aboard the *Bremen*. Introspection led him to start recording on paper the more extraordinary episodes of his career. With the help of his step-daughter, Alice, and the distinguished Irish author John Stewart Collis, Lavery began writing his memoirs. Collis and Lavery became such close friends that Collis actually 'ghosted' Lavery's autobiography, *The Life of a Painter* (1940). This portrait, dedicated to the writer, dates from the period of their collaboration and was later used as the frontispiece to Collis's own autobiography, *Bound upon a Course* (1971).

M	T	W	T	F	S	S
31	1	2	3	4	5	6
7	8	9	10	11	12	13
14	15	16	17	18	19	20
21	22	23	24	25	26	27
28	29	30	1	2	3	4

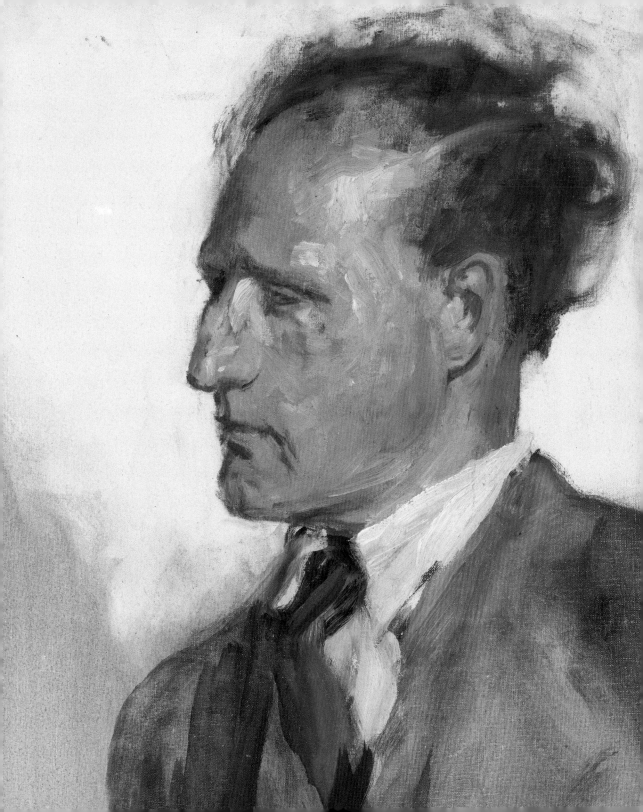

14 Monday · Luan

15 Tuesday · Máirt

16 Wednesday · Céadaoin

17 Thursday · Déardaoin

18 Friday · Aoine

19 Saturday · Satharn

20 Sunday · Domhnach

Filippino Lippi, *Portrait of a Musician,* **late 1480s**

The instruments around this man suggest that he was an important musician, composer, poet or
humanist of the period. Music was a constant presence in Renaissance life and performing was
not confined to professional musicians: aristocrats and humanists also played. The man tunes a
finely carved lira da braccio, then considered the most notable solo instrument and widely used to
accompany recitations of poetry. Behind him are books, sheet music, a lute, another lyre and two wind
instruments, further reinforcing his professional status.

M	T	W	T	F	S	S
31	1	2	3	4	5	6
7	8	9	10	11	12	13
14	15	16	17	18	19	20
21	22	23	24	25	26	27
28	29	30	1	2	3	4

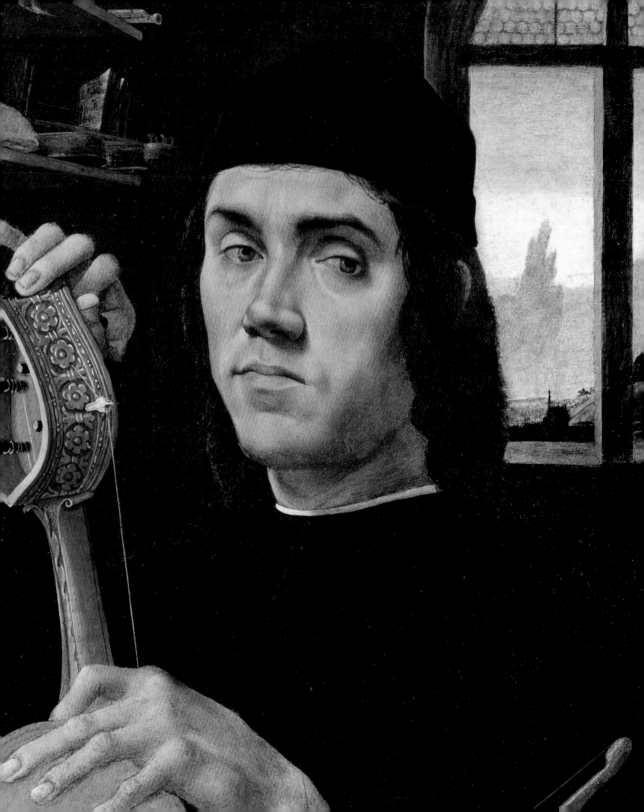

21 Monday • Luan

22 Tuesday • Máirt

23 Wednesday • Céadaoin

24 Thursday • Déardaoin

25 Friday • Aoine

26 Saturday • Satharn

27 Sunday • Domhnach

Pieter de Hooch, *Players at Tric-trac,* **c.1652–55**

Two soldiers and a woman play tric-trac, or backgammon, a game associated in de Hooch's time with idleness and seen as leading to licentiousness and sin. Gambling between the sexes was understood as a preliminary to seduction of women by men, while drinking and smoking were also seen as morally condemnable. In this scene, one soldier holds a tankard of wine while the other smokes tobacco from a clay pipe. Another used pipe lies discarded on the floor alongside two playing cards, which further emphasise the theme of gambling.

M	T	W	T	F	S	S
31	1	2	3	4	5	6
7	8	9	10	11	12	13
14	15	16	17	18	19	20
21	22	23	24	25	26	27
28	29	30	1	2	3	4

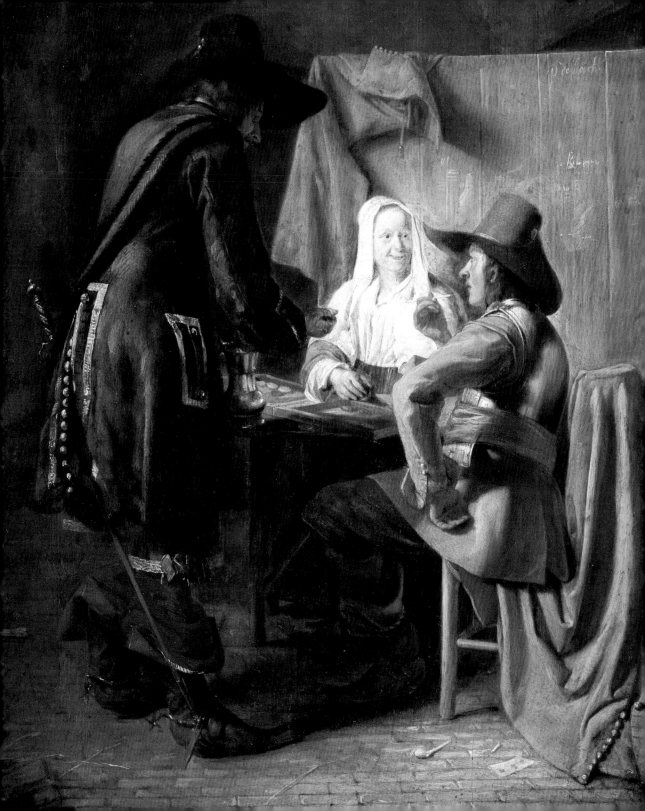

November • Samhain
Week 48 • Seachtain 48

28 Monday • Luan

29 Tuesday • Máirt

30 Wednesday • Céadaoin

1 Thursday • Déardaoin December • Nollaig

2 Friday • Aoine

3 Saturday • Satharn

4 Sunday • Domhnach

Orazio Gentileschi, *David and Goliath,* **c.1605–07**

The First Book of Samuel tells of Goliath, a warrior of the Philistines, who offered to fight any man from the Israelites. David volunteered, armed only with his sling and stones. With the first stone he knocked Goliath to the ground, having hit him in the forehead. This story of bravery was popular among Caravaggio's followers, of whom Gentileschi is notable. Having become friends with Caravaggio, his style absorbed many of the latter's stylistic traits. Gentileschi's oblique composition, vibrant thrust and tempestuous atmosphere convey the action of the figures, sharply lit from above, all revealing the influence of the master.

M	T	W	T	F	S	S
31	1	2	3	4	5	6
7	8	9	10	11	12	13
14	15	16	17	18	19	20
21	22	23	24	25	26	27
28	29	30	1	2	3	4

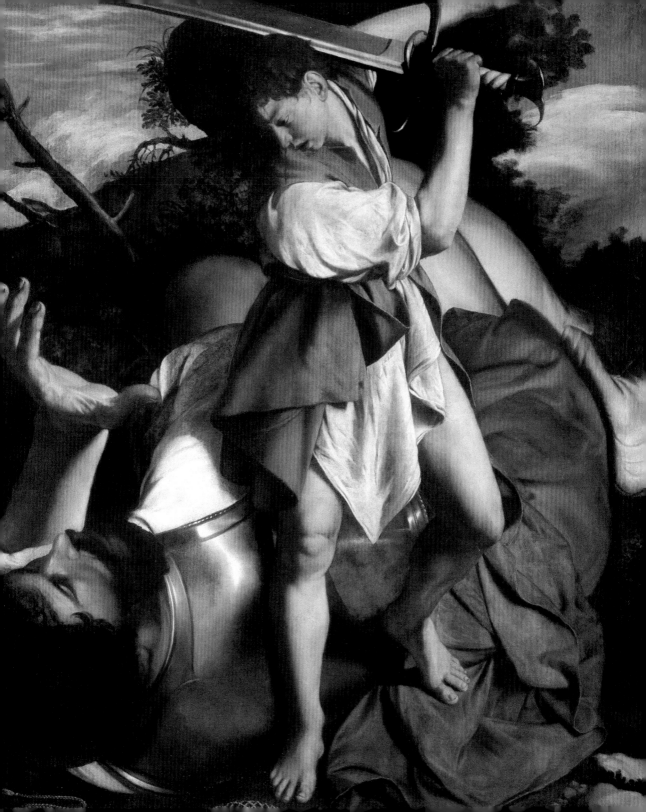

5 Monday · Luan

6 Tuesday · Máirt

7 Wednesday · Céadaoin

8 Thursday · Déardaoin

9 Friday · Aoine

10 Saturday · Satharn

11 Sunday · Domhnach

Hugh Douglas Hamilton, *Cupid and Psyche,* **c.1792**

This is a preparatory study for Hamilton's oil painting *Cupid and Psyche in the Nuptial Bower,* also in the National Gallery of Ireland, showing that Hamilton spent much time working out the details of his final painting. His choice of subject was probably influenced by contemporary sculptures of Cupid and Psyche by his friend Antonio Canova. Hamilton's figures may be based on a Pompeiian fresco of a faun pulling a nymph towards him, which the artist may have known through contemporary engravings made of the discoveries at Pompeii.

M	T	W	T	F	S	S
28	29	30	1	2	3	4
5	6	7	8	9	10	11
12	13	14	15	16	17	18
19	20	21	22	23	24	25
26	27	28	29	30	31	1

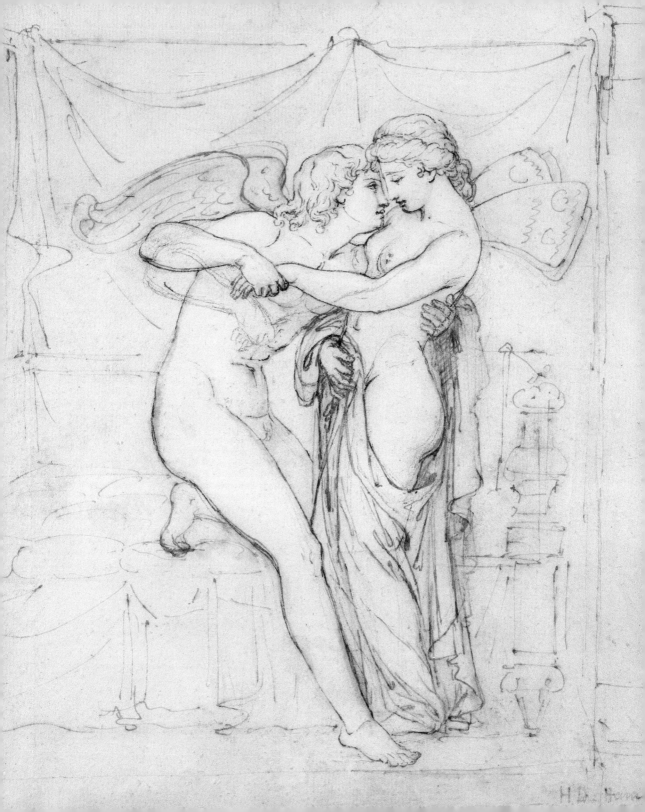

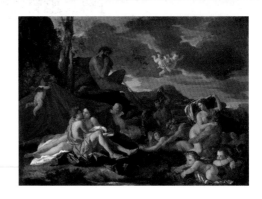

12 Monday · Luan

13 Tuesday · Máirt

14 Wednesday · Céadaoin

15 Thursday · Déardaoin

16 Friday · Aoine

17 Saturday · Satharn

18 Sunday · Domhnach

Nicolas Poussin, *Acis and Galatea,* **1627–28**

In Rome, Poussin specialised in cabinet paintings of subjects from ancient mythology. This bacchanal, derived from Ovid's *Metamorphoses*, relates the love of the sea-nymph Galatea for the Sicilian shepherd Acis. They embrace, unseen by Polyphemus, the one-eyed giant of the race of Cyclops, who was in love with Galatea. Polyphemus plays a love song to her on his pipes of Pan, while tritons, nereids and putti riding on dolphins frolic in the water.

M	T	W	T	F	S	S
28	29	30	1	2	3	4
5	6	7	8	9	10	11
12	13	14	15	16	17	18
19	20	21	22	23	24	25
26	27	28	29	30	31	1

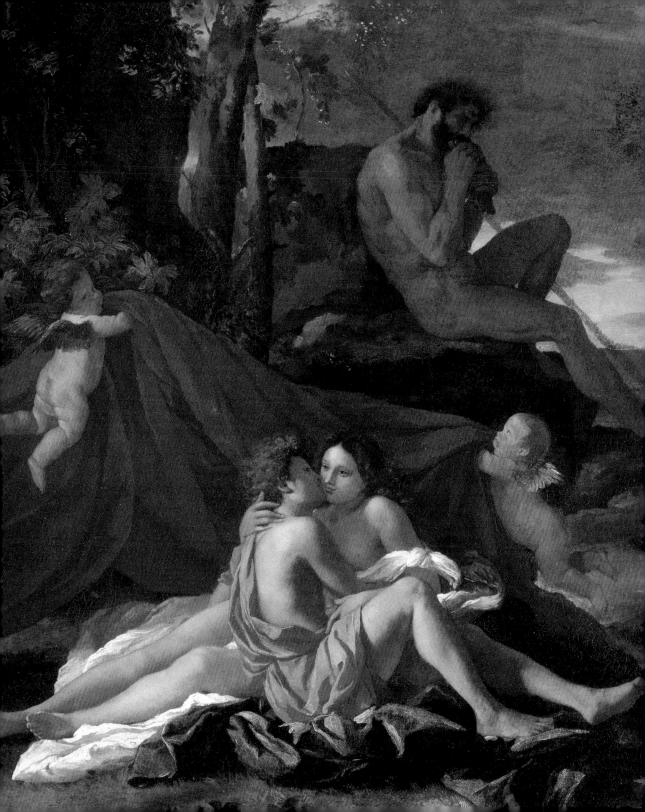

19 Monday · Luan

20 Tuesday · Máirt

21 Wednesday · Céadaoin

22 Thursday · Déardaoin

23 Friday · Aoine

24 Saturday · Satharn
Christmas Eve

25 Sunday · Domhnach
Christmas Day

Jan de Beer, *The Flight into Egypt,* **c.1519**

The Gospel of St Matthew (2:13–15) narrates how Joseph took Mary and the Infant Christ into Egypt
to safeguard them from being killed by King Herod. This account was amplified in several apocryphal
texts, which are the literary source for the theme in art of Mary carrying the Christ Child in her arms
and riding a donkey, which Joseph leads by the halter. The warm, bright colours, elegant drapery,
delicate lighting, and slight bird's-eye perspective in this painting are all typical of Jan de Beer's work.

M	T	W	T	F	S	S
28	29	30	1	2	3	4
5	6	7	8	9	10	11
12	13	14	15	16	17	18
19	20	21	22	23	24	25
26	27	28	29	30	31	1

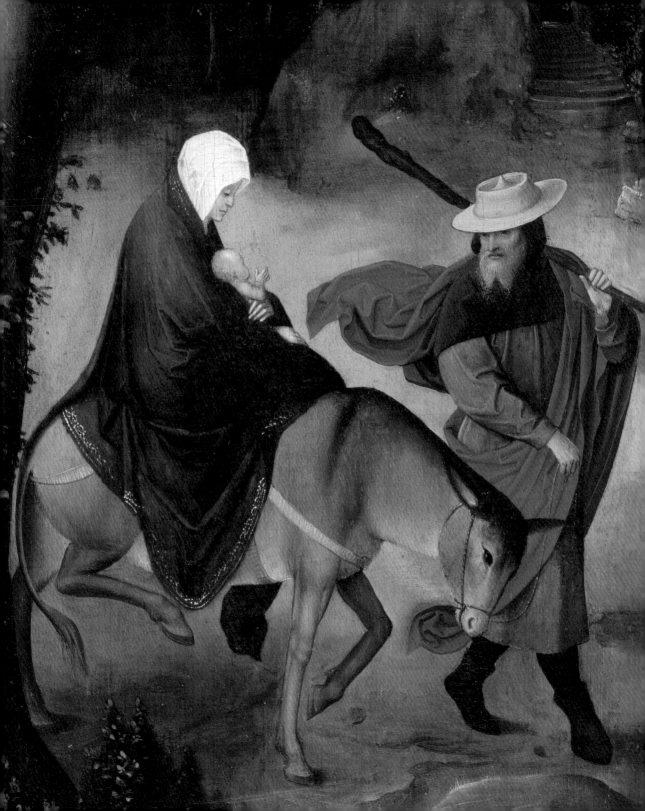

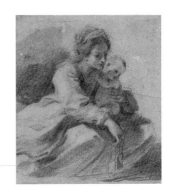

26 Monday · Luan
St Stephen's Day

27 Tuesday · Máirt

28 Wednesday · Céadaoin

29 Thursday · Déardaoin

30 Friday · Aoine

31 Saturday · Satharn
New Year's Eve

1 Sunday · Domhnach
New Year's Day

2023 January · Eanáir

Guercino, *The Virgin and Child (for the Madonna del Carmine Presenting a Scapular to a Carmelite, in Cento's Pinacoteca Civica),* **c.1615**

This is a preparatory drawing for an altarpiece now in the Pinacoteca Civica in Cento, Guercino's home town in northern Italy. The Madonna del Carmine (Our Lady of Mount Carmel) is shown with the Christ Child presenting a scapular to the Carmelite monk St Albert. A scapular was originally a type of apron worn by monks consisting of pieces of cloth worn front and back, joined by straps over the shoulders. It forms part of the habit of some religious orders, including the Carmelites, for whom it remains a sign of Mary's motherly protection.

M	T	W	T	F	S	S
28	29	30	1	2	3	4
5	6	7	8	9	10	11
12	13	14	15	16	17	18
19	20	21	22	23	24	25
26	27	28	29	30	31	1

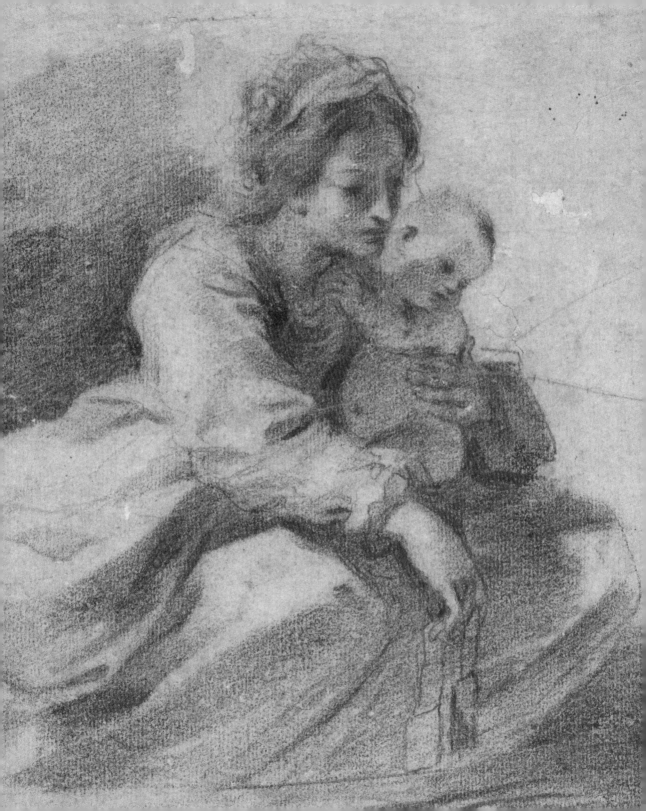

List of Works

Giuseppe Macpherson, Italian,1726–c.1778, *Maria Theresa (1717-1780), Empress of Germany, Queen of Bohemia and Hungary,* 1740s, Enamel on copper, Unframed: 4.2 x 3.8 cm, NGI.3624

Harry Clarke, Irish, 1889-1931, *The Song of the Mad Prince,* 1917, Stained glass panel, 34.3 x 17.7 cm, NGI.12074

George Russell (AE), Irish (1867-1935), *Portrait of Iseult Gonne (Mrs Francis Stuart),* 20th C, Oil on canvas, 56 x 46 cm, NGI.1787

Roderic O'Conor, Irish, 1860-1940, *Still life with Apples and Breton Pots,* c.1896-1897, Oil on board, 49.5 x 55.5 cm, NGI.4721

Sarah Purser, Irish, 1848-1943, *Portrait of Kathleen Behan,* 20th C, Oil on board, 26 x 24 cm, NGI.4188

Gustave Caillebotte, French,1848-1894, *Banks of a Canal, near Naples,* c.1872, Oil on canvas, 39.7 x 59.7 cm, NGI.2008.90

James Arthur O'Connor, Irish, 1792-1841, *A Frost Piece,* c.1825, Oil on board, 20 x 17 cm, NGI.4132

Charles Buchel, British, 1872-1950, *Portrait of Ernest Shackleton (1874 - 1922), Polar Explorer,* 1921, Oil on canvas, 60.9 x 50.8 cm, NGI.4715

Jacques-Emile Blanche, French, 1861-1942, *Portrait of James Joyce (1882-1941), Author,* 1934, Oil on canvas, 82 x 65 cm, NGI.1051

Bartolomé Esteban Murillo, Spanish, 1617-1682, *The Infant St John Playing with a Lamb,* 1670s, Oil on canvas, 61 x 44 cm, NGI.33

Michael Angelo Hayes, British, 1820-1877, *Sackville Street, Dublin,* c.1853, Watercolour, gouache and graphite on paper, 54.5 x 77.6 cm, NGI.2980

Félix François Georges Philibert Ziem, French, 1821-1911, *Venice: a Scene with Boats,* c.1846-1911, Oil on canvas, 83 x 117 cm, NGI.4289

Hercules Brabazon Brabazon, British, 1821-1906, *A Street in Hamburg, Germany,* 19th C, Graphite and crayon on paper, 23.2 x 26.2 cm, NGI.2761

Mainie Jellett, Irish, 1897-1944, *A Water-Lily Pond,* c.1930s, Gouache on paper, 18 x 25 cm, NGI.7849

James Barry, Irish, 1741-1806, *The Baptism of the King of Cashel by Saint Patrick,* c.1800-1801, Oil on paper, laid on canvas, 62 x 63 cm, NGI.4623

Pierre Bonnard, French, 1867-1947, *Nude before a Mirror,* 1915, Oil on canvas, 59.9 x 51 cm, NGI.2009.13

Francisco José de Goya y Lucientes, Spanish, 1746-1828, *Doña Antonia Zárate,* c.1805-06, 103.5 x 82 cm, Oil on canvas, NGI.4539

Dante Gabriel Rossetti, British, 1828-1882, *Jane Burden as Queen Guinevere,* 1858, Ink, graphite and wash with white highlights on paper, 48.3 x 35.3 cm, NGI.2259

Robert Ponsonby Staples, Irish, 1853-1943, *Ireland's Eye from Howth,* 1899, Graphite, pastel, chalk and watercolour on paper, 26.3 x 35.5 cm, NGI.2009.16

William Crozier, Irish, 1930-2011, *Flanders Fields,* 1962, Mixed media on canvas, 152 x 151.8 cm, NGI.2012.24

Joseph Mallord William Turner, British, 1775-1851, *Beech Trees at Norbury Park, Surrey,* c.1797, Graphite and watercolour on sheet lined with laid paper, 44 x 43.1 cm, NGI.2409

Moyra Barry, Irish, 1886-1960, *Self-Portrait in the Artist's Studio,* 1920, Oil on canvas, 30.4 x 25.5 cm, NGI.4366

Bernardo Strozzi, Italian, 1581-1644, *Allegory of Spring and Summer,* late 1630s, Oil on canvas, 72 x 128 cm, NGI.856

Walter Frederick Osborne, Irish, 1859-1903, *Portrait of John William Scharff (b.1895),* 19th C, Oil on canvas, 60.5 x 50.2 cm, NGI.1935

Augustus Burke, Irish, 1838-1891, *A Connemara Girl,* c.1880s, Oil on canvas, 63 x 48 cm, NGI.1212

Maurice MacGonigal, Irish,1900-1979, *Fishing Fleet at Port Oriel, Clogherhead, Co. Louth,* c.1940, Oil on canvas, 48 x 63.5 cm, NGI.4564

William Orpen, Irish, 1878-1931, *The Wash House,* 1905, Oil on canvas, 91 x 73 cm, NGI.946

Alfred Sisley, French, 1839-1899, *The Banks of the Canal du Loing at Saint-Mammès,* 1888, Oil on canvas, 38.2 x 56 cm, NGI.966

Sarah Purser, Irish, 1848-1943, *Portrait of Dr Douglas Hyde (1860-1949), Poet, Scholar and First President of Ireland,* c.1939, Oil on canvas, 76 x 63 cm, NGI.1181

Jean Bardon, Irish, b.1952, *Annunciation Lilies,* 2008, Etching with gold leaf, Sheet: 65.2 x 50 cm, Plate: 40.4 x 21.1 cm, NGI.2008.20

Johan Barthold Jongkind, Dutch, 1819-1891, *A Windmill in Moonlight,* 1868, Oil on canvas, 33 x 25 cm NGI.4250

Joseph Mallord William Turner, British, 1775-1851, *Ostend Harbour,* c.1840, Watercolour with scraping out on ivory wove paper, 25 x 36.6 cm, NGI.2425

Jean-Antoine Watteau, French, 1684-1721, *Woman Seen from the Back,* c.1715-1716, Graphite and red chalk on paper, 14 x 9.6 cm, NGI.2299

Eva Gonzalès, French, 1849-1883,*Children on the Sand Dunes, Grandchamp,* 1877-78, Oil on canvas, 46 x 56 cm, NGI.4050

Walter Osborne, Irish, 1859-1903, *The Dublin Streets: A Vendor of Books,* 1889, Oil on canvas, 80 x 90 cm, NGI.4736

Casimir Dunin Markievicz, Polish, 1874-1932, *The Artist's Wife, Constance, Comtesse de Markievicz (1868-1927), Irish Painter and Revolutionary,* 1899, Oil on canvas, 205 x 91cm, NGI.1231

Claude Monet, French, 1840-1926, *Argenteuil Basin with a Single Sailboat,* 1874, Oil on canvas, 55 x 65 cm, NGI.852

Frederic William Burton, Irish, 1816-1900, *Cassandra Fedele, Poet and Musician,* 1869, Black chalk on paper, 102 x 69 cm, NGI.2385

Walter Osborne, Irish, 1859-1903, *By the Sea,* c.1900, Watercolour on paper, 25.3 x 35.5 cm, NGI.2537

José Antolínez, Spanish, 1635-1676, *The Liberation of Saint Peter,* early 1670s, Oil on canvas, 167 x 128 cm, NGI.31

Harry Clarke, Irish, 1889-1931, *The Shepherdess and the Chimney Sweeper,* 1916, Ink, graphite, watercolour, gouache and glazes with bodycolour highlights, 38.8 x 27.8 cm, NGI.2008.89.6

Vincent van Gogh, Dutch, 1853-1890, *Rooftops in Paris,* 1886, Oil on canvas, 45.6 x 38.5 cm, NGI.2007.2

Pierre Bonnard, French, 1867-1947, *Boy Eating Cherries,* 1895, Oil on board, 52 x 41 cm, NGI.4356

Roderic O'Conor, Irish, 1860-1940, *Reclining Nude before a Mirror,* 1909, Oil on canvas, 54 x 74 cm, NGI.4038

Sarah Henrietta Purser, Irish, 1848-1943, *A Lady Holding a Doll's Rattle,* 1885, Oil on canvas, 41 x 31 cm, NGI.4131

Frans Hals, Dutch, c.1581-1666, *The Lute Player,* 1630s, Oil on canvas, 83 x 75 cm, NGI.4532

Anton Mauve, Dutch, 1838-1888, *Shepherd and Sheep,* c.1885-1888, Oil on panel, 33 x 41 cm, NGI.4257

Matthew James Lawless, Irish, 1837-1864, *A Sick Call,* 1863, Oil on canvas, 63 x 103 cm, NGI.864

John Lavery, Irish, 1856-1941, *Portrait of John Stewart Collis (1900-1984), Author,* 1940, Oil on canvas, 60 x 50 cm, NGI.4501

Filippino Lippi, Italian, c.1457-1504, *Portrait of a Musician,* late 1480s, Tempera and oil on wood panel, 51 x 36 cm, NGI.470

Pieter de Hooch, Dutch, 1629-1684 or after, *Players at Tric-trac,* c.1652-55, Oil on wood panel, 45 x 33.5 cm, NGI.322

Orazio Gentileschi, Italian, 1563-1639, *David and Goliath,* c.1605-1607, Oil on canvas, 185.5 x 136 cm, NGI.980

Hugh Douglas Hamilton, Irish, 1740-1808, *Cupid and Psyche,* c.1792, Pen and brown ink with white bodyclour and graphite on paper, 32 x 25.5 cm, NGI.19617

Nicolas Poussin, French, 1594-1665, *Acis and Galatea,* 1627-28, Oil on canvas, 98 x 137 cm, NGI.814

Jan de Beer, Flemish, c.1475-1528, *The Flight into Egypt,* 1519-1527, Oil on oak panel, 33.5 x 23.7 cm, NGI.1001

Guercino, Italian, 1591-1666, *The Virgin and Child (for the Madonna del Carmine Presenting a Scapular to a Carmelite, in Cento's Pinacoteca Civica),* c.1615, Red chalk on beige paper, 20 x 17.8 cm, NGI.2603

COVER: **John Butler Yeats,** Irish, 1839-1922, *Portrait of Susan Mary (Lily) Yeats (1866 -1949), Embroiderer and Designer,* 1901, Oil on canvas, 91.7 x 71 cm, NGI.1180

BACK COVER: **George Inness,** American, 1825-1894, *A Seacoast, Evening,* 19th C, Oil on canvas, 46 x 66cm, NGI.1293

END PAPERS: **Engraver: Henry Brocas the Younger,** Irish, c.1798-1873, **After: Samuel Frederick Brocas,** Irish, c.1792-1847, *The Corn Exchange, Burgh Quay and Custom House, Dublin,* 19th C, Etching and line with watercolour, 33 x 48.5 cm NGI.11946

Dimensions exclude frames.

All images © National Gallery of Ireland unless stated otherwise.

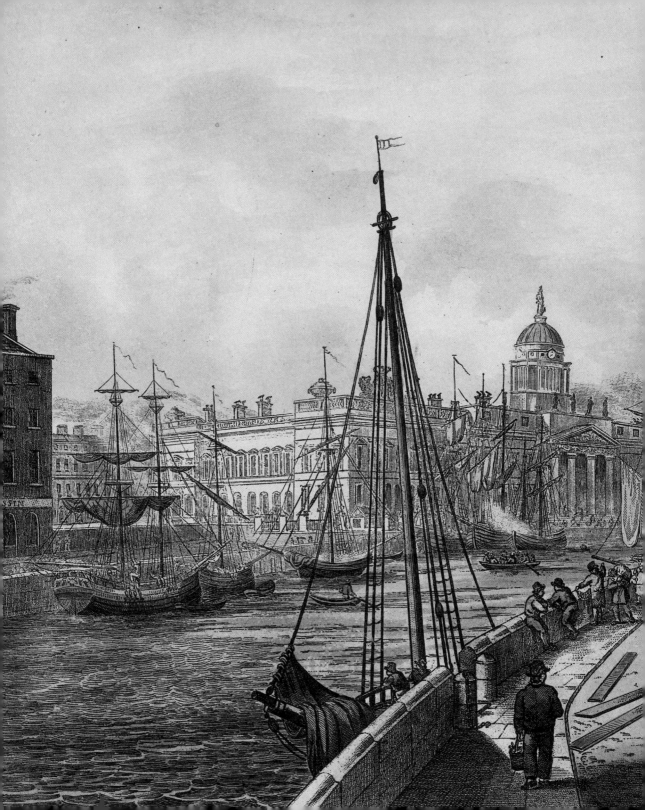